THE EDGE OF EVERYTHING

Reflections on Curatorial Practice

To Auntie Mary Agnes & Uncle Ivan,

This was a fun project for me!

le JV

EDITED BY CATHERINE THOMAS

keeper

THE EDGE OF EVERYTHING

Reflections on Curatorial Practice

what does not respect borders, positions, rules; the in-between, the ambiguous, the composite ◻ between the audience and the stage, between the spectacle and its reception ◻ forgotten spaces like the edge of building lots, old playgrounds, and parks ◻ weaving, more than the stitching, is a key activity in this kind of exhibition-making ◻ complex histories, traditional knowledge, and contemporary issues ◻ situational displacement, heightening awareness of the shifting frame that defines the spaces where art is shown ◻ the plug: between boundary and boundlessness ... the politics of imagination ◻ the opaque surface that conceals relationships ◻ to capture something just on the cusp of articulation, as it is in the process of discursive formation ◻ love of chance lures him to doorways, spaces where reputedly deep-change accidents occur ◻ the curator, inside, can be the outsider, and we all end up sticking our heads into a wall

National Library of Canada Cataloguing in Publication Data

Main entry under title:
The edge of everything

Includes bibliographical references.
ISBN 0–920159–92–3

1. Art--Exhibition techniques. 2. Art museum curators. I. Thomas, Catherine, 1972–
N470.E33 2002 708'.0075'3 C2002–910786–5

Cover and interior design: Carol Dragich
Copyedited by: Maureen Nicholson
Printed and bound in Canada by: Kromar Printing Ltd.

Back and front cover photographs from left to right courtesy Andrew Hunter, Jeremy Deller, Joanne Bristol, Leonilson/Rômulo Fialdini, Rosalie Favell, AA Bronson, Pip Day, Korpys/Löffler and Achim Bitter photo by Joachim Fliegner, Joshua Decter, Thecla Schiphorst, Ihor Holubizky. All photograph credits appear in captions. Every effort has been made to trace ownership and to obtain permission to reprint copyright material. The publisher would be pleased to have any errors or omissions brought to their attention so that they may be corrected in subsequent printings.

The Banff Centre Press gratefully acknowledges the Canada Council for the Arts for its support of our publishing program. The Banff International Curatorial Institute and the Walter Phillips Gallery sincerely express their appreciation and acknowledge the Canada Council for the Arts for supporting this publication.

THE CANADA COUNCIL | LE CONSEIL DES ARTS
FOR THE ARTS | DU CANADA
SINCE 1957 | DEPUIS 1957

THE BANFF CENTRE Box 1020
PRESS Banff, Alberta T1L 1H5
 www.banffcentre.ca/press

Contents

Foreword

IN THE SPRING OF 1999, Catherine Thomas approached Jon Tupper, former director of the Walter Phillips Gallery at the Banff Centre for the Arts, and I, with an idea to develop a book of essays by curators reflecting on their curatorial practices. Jon and I recognized that few public venues exist for the contemplation of curatorial research and development in Canada, and even fewer forums allow for reflection by Canadian curators within an international context. We welcomed Catherine's proposal. As a result of Catherine's efforts, and the brainstorming sessions Catherine, Jon, and I organized, *The Edge of Everything: Reflections on Curatorial Practice*, provides such a forum. The book makes public some of the most private aspects of the contributor-curators' practices. It is not intended to be an extensive examination of curatorial practice. Rather, we hope that this book (along with the others supported by the Banff International Curatorial Institute at the Walter Phillips Gallery) will serve as a useful reference for those interested in the issues that have shaped, and are shaping, contemporary curatorial practice.

On behalf of both the Walter Phillips Gallery and the Banff International Curatorial Institute, I would like to extend our heartfelt thanks to the anthology's editor and progenitor, Catherine Thomas. Her adept and intuitive handling of the texts included here has culminated in an interesting and original collection of widely diverse, revealing, and often personal reflections on the practices

of curators. We are also indebted to the authors featured in this book. Their collective candour is a welcome contrast to the all-too-often superficial and scholarly musings on why we do what we do. The contributors to *The Edge* offer moments for pause to the readers of this book, who, we hope, will be prompted to reconsider and reflect on their own curatorial practice.

Thanks also to the Banff Centre Press, particularly managing editor Lauri Seidlitz and acting managing editor Meaghan Craven, for guiding this volume through production. Finally, we are most grateful for the financial support of the Canada Council for the Arts for making this book possible.

MELANIE TOWNSEND, CURATOR, WALTER PHILLIPS GALLERY

◻

Introduction

THE ROLE OF THE CURATOR IS CHANGING. This statement is hardly new. In recent years, countless texts, conferences, and symposia organized worldwide have examined this changing role. Historically, the curator's "hand" or process of selection aimed for complete absence from the "objective" display on view. This notion of an invisible practice remained intrinsically bound to the traditional concept of the museum — a rational, neutral, and authoritative place of absolute truths and values. This traditional concept has also long been in question, and with this challenge to the rationality of the museum comes a growing awareness of the curator's part in shaping exhibitions.[1] As well, art continues to evolve and requires radically new approaches to exhibition-making, thus changing the relationship of art, artist, curator, and viewer.

As a result of the evolution of art and the museum, we now have an increasingly heightened awareness of the curator's role, with that awareness sometimes taking precedence over the art itself and some curators gaining near-celebrity status. However, despite being aware that curators play a major part in what and how art gets presented, we still resist acknowledgement of the subjective nature of exhibition-making. The rhetoric surrounding curatorial practices rarely seeks to move beyond canonical discussions to reveal the contingencies that inform individual curatorial practices. Within that rhetoric, the range of words used to describe "curator" are vast: caregiver, collaborator, facilitator, negotiator, cultural communicator, cultural agitator. All of these understandings of curating imply

some forms of social exchange. However, for the most part, these exchanges are rarely discussed or acknowledged.

If curating has moved from an invisible praxis to a more visible one, then what is at stake in disclosing the subjective forces that inform it? What remains hidden and why? What discoveries are made outside or at the peripheries of the context of an exhibition that are as fruitful as the exhibition itself? And if curators have indeed become negotiators, collaborators, mediators, and enablers, then how do such exchanges influence what they present? Curating encompasses many things, most of which are discursive: experimenting, investigating, exploring, amplifying, facilitating, and more. Similarly, this book is not a guide to curating, nor does it pretend to provide answers to the questions above. What follows is a selection of views into the processes, and the spaces in-between the processes (the edges) that inform curators and what they do.

Eleven curators from various parts of the world, with varying backgrounds and at different stages of their careers, were invited to reflect on their experiences and their relationships to their practice. The selection of curators was informed by both personal interest and the generous guidance of an advisory committee that included Jessica Bradley, Bruce Ferguson, Thyrza Goodeve, Anjum Katyal, Cuauhtémoc Medina, Ivo Mesquita, and Stella Rollig. The book's scope in no way intends to represent the multiplicity of voices in the international curatorial community. It is a modest collection of essays by some curators active today.

For this book, the curators were asked to write with a decisively personal, even diaristic tone. This direction resulted from a deliberate strategy to take the critical discourse surrounding curating somewhere it rarely goes, and to reveal the phenomena that inform the practice. In many cases, this book was the first opportunity for these curators to reflect on their individual careers, and many found it challenging to speak in a more personal way. Collectively, the authors present a wide range of approaches and ideas about curatorial practice — as diverse as their individual projects and as unique as they are. The very nature of these intimate stories defies categorization or thematic groupings. In many ways, these essays also resist synopsis. However, if there is a common element here, it is that art and the curator's relationship to art is as ever-changing as life itself and therefore requires constantly evolving manners of thinking and working. Curators have become an active force, selecting and inserting themselves within the realities in which they choose to engage. Through reading the following personal reflections, we discover that curators are fuelled by, among other things: idiosyncrasies, passions, intuition, energies, curiosity, childhood experiences, heritage, education, and political, social, and spiritual beliefs. By affirming the personal

dimensions of curating, and the complex web of occurrences that encompass it, the essays yield an understanding of the practice that is in keeping with one of the primary concerns of contemporary art: to challenge the belief that art and life exist in separate realms.

We live in an era in which disciplinary boundaries are dissolving and allowing for the emergence of new approaches, concepts, imaginings, and speculations. Designer Bruce Mau argues that new conditions demand new ways of thinking; thinking demands new forms of expression; and new expressions generate new conditions.[2] The term *curator* has always been on the edge of an ever-changing, ever-expanding definition; however, the expression may have outlived the conditions that produced it. Evidence to support this claim can be found in the first essay by Anthony Kiendl, who identifies with the curative nature of the term (derived from the Greek "to care for"), and who also conflates the term's meaning by locating his practice in surprising and disparate concepts. This paradoxical way of thinking about curating is only intensified by the rest of the authors in this book.

Perhaps we have arrived at a time that demands a new term, a new expression to describe curating — a term that embodies the dynamic, experiential, and explorative capacities of curatorial practice, and thus continually opens up new modes and possibilities.

CATHERINE THOMAS

1 For an excellent discussion of the evolution of the museum, see: Karsten Schubert's, *The Curator's Egg: The Evolution of the Museum Concept from the French Revolution to the Present Day* (London: One Off Press, 2000).

2 Number 28 of Bruce Mau's 43 point manifesto, "An Incomplete Manifesto for Growth," reads: "Make new words. Expand the lexicon." Bruce Mau, in Kyo Maclear and Bart Testa, ed., (London: Phaidon Press, 2000), 90.

□

Acknowledgements

THE TWO-YEAR PROCESS of taking *The Edge of Everything: Reflections on Curatorial Practice* from an idea to a publication has been exhilarating. Bringing together the ideas of eleven curators based in various parts of the world, however, was often challenging and I have relied heavily on the support, understanding, and expertise of many.

I am deeply grateful to the curators who so generously contributed original and thought-provoking texts. It has been a great honour to work with a group of individuals whose commitment to rethinking curating is shaping how we bring art to our collective landscape.

Thank you to Jessica Bradley, Bruce Ferguson, Thyrza Goodeve, Anjum Katyal, Cuauhtémoc Medina, Ivo Mesquita, and Stella Rollig for offering your guidance at the initial stages of this project.

I am also indebted to my editors at the Banff Centre Press, Lauri Seidlitz and Meaghan Craven, who were warm-hearted and cool-headed no matter what the situation. With unfaltering patience and professionalism, they painstakingly attended to every aspect of this book. Their talent and dedication has helped to strengthen this text. Thank you to Maureen Nicholson for her rigorous copy editing, and to Carol Dragich for her creative approach to designing the book.

My deepest appreciation goes to Jon Tupper and Melanie Townsend for supporting my vision throughout the process, and for sharing their experience and knowledge of the curatorial field with me.

Finally, I am especially thankful to my friends and family for their never-ending support and encouragement.

Developing this anthology has provided me with a forum for discussion with artists, curators, gallery directors, editors, and publishers. I have both delighted in and benefited from these stimulating conversations, and thank each of you for enriching my process.

CATHERINE THOMAS

THE EDGE OF EVERYTHING

Reflections on Curatorial Practice

ANTHONY KIENDL is the director of Visual Arts and the Walter Phillips Gallery at The Banff Centre. He is also the director of the Banff International Curatorial Institute. In 2002, he served as Acting Director of the Dunlop Art Gallery at the Regina Public Library, where he had been curator since 1997. His curatorial practice has theorized weakness, pathos, failure – and related sentiments such as nostalgia – as responses to modernism. This strategy has been manifested in diverse forms including the exhibition *Little Worlds* (1998), an exploration of diminutive environments by artists; *Fluffy* (1999), a research project on the aesthetics and meaning of cuteness; *Space Camp 2000: Uncertainty, Speculative Fictions and Art* (2000), an inter-disciplinary festival of speculative fictions and alterity; and *Godzilla vs. Skateboarders: Skateboarding as a Critique of Social Spaces* (2001). His upcoming projects include *Big Rock Candy Mountain*, a creative artist residency, exhibition, and publication on the cultural meaning of candy in North American society (cocurated with Dr. Jeanne Randolph). He is also working on a feature-length film project with Joanne Bristol entitled *Comfy Hostage*, and is gallerist of Spacer, an alternative mobile exhibition space.

■

On Weakness,
or, "You will become a friend of mud"

ANTHONY KIENDL

AS A CHILD GROWING UP in suburban Winnipeg, I lived in a neighbourhood with brand new bungalows, duplexes, and Donwood Elementary up the street. Childhood, among other things, meant regular checkups at the doctor and dentist. These visits involved travelling from the suburbs to the doctor downtown, or even farther — to the south of Winnipeg — for the dentist.

When I think about these drives, I recall blistering summer heat, with my little legs sticking to vinyl car seats and the tune of Hot Butter's catchy pretechno hit "Popcorn" on the radio. (Now, some twenty years later, I would like to produce a compilation of remixes of that cut with contemporary electronica artists.)

Going to the doctor or dentist caused me less trepidation then than now. Sitting in the waiting rooms was eventful. Those visits were a crucible of cultural experience that I can trace in my curatorial practice today.

Ian Lawrence Goldberg was our family doctor. His office was in the Boyd Building on Portage Avenue, across from where a big mall was eventually built. I remember when Dr. Goldberg passed away. His death from cancer was unexpected to me — he was young. Mom was upset; it was like losing a close friend. He took care of all us kids, including my younger sister Lynn who has cerebral palsy.

Mom clipped out Dr. Goldberg's obituary. It reads:

> On July 5, 1981 at the St. Boniface Hospital, after a lengthy illness, Dr. Ian Goldberg, aged 44 years.
>
> Dr. Goldberg was born in Winnipeg and attended Luxton School, St. John's Tech and the University of Manitoba graduating from the Faculty of Medicine in 1959 ...
>
> Dr. Goldberg held a Fellowship in Pediatrics and was the Chief Pediatrician of Misericordia Hospital. He was a staff physician at the Children's Hospital, a staff Physician at Victoria General Hospital and an Assistant Professor, Department of Pediatrics, Faculty of Medicine, University of Manitoba ...
>
> Dr. Goldberg's many involvements included Directorships in the Jewish National Fund, United Jewish Appeal and ANAV ...
>
> Private shiva.

□ □ □ □ □

I remember the hectic pace of the waiting room at Dr. Goldberg's office. The waits were often long. I also remember the pictures on the wall. I spent a lot of time exploring their intricacies. The pictures depicted big-eyed children. I recall one of a boy, apparently down on his luck and penniless, scrounging on what I imagined were the streets of Paris. There was another picture of a girl in the same setting. I remember some with tears in their eyes. Many will remember those paintings of big-eyed children, by American artist Margaret Keane, as a popular culture phenomenon of the late fifties to early seventies.[1]

They were caricatures, conforming to the textbook definition of cuteness. (Yes, cuteness has been defined in textbooks, particularly in those concerned with evolution theory, as part of the study of *neoteny*. This term refers to the progressive juvenilization, or retention of juvenile features, by a creature as a strategy of species survival. I explored this research for *Fluffy*, my exhibition on the aesthetics of cuteness.) The children had big foreheads, with big eyes set widely apart. They had comparatively small mouths and relatively short, stubby limbs. Cute. The teary-eyed kids were dreary, but I imagine they were chosen to reassure young patients waiting to be poked and prodded. I will never forget those big eyes.

▫ ▫ ▫ ▫ ▫

Allan Erwin Diner was our family dentist. In his office the artwork was different. In his last few years, he painted and drew. Though I did not see these works, I vividly remember another painting in his office by his daughter Janis. It consisted of four horizontal lines, about nine inches across, each monochromatic. The lines touched one another, except the bottom one, which was detached and floating about an inch below the rest. The three on top were stacked like pancakes. The painting was a study in colour and control. Although the colours kissed each other, they didn't mix. Each line was straight and of equal length, with both ends rounded like pills. This painting captured my attention. It was a riddle. I had never seen anything like it. Why did someone make it like that? Why was it hanging there? What could it possibly mean? And as I waited there for my appointment, my mind struggled to come to terms with it. It was so different from the big-eyed kids on the walls of Dr. Goldberg's office.

David Miller, Dion, *Photogram of cremation ash; selenium toned, fibre-based gelatin silver print, 71 x 71 cm. Courtesy the Dunlop Art Gallery, from the exhibition,* Space Camp 2000: Uncertainty, Speculative Fictions and Art.

On Sunday morning, February 8, 1998 at St. Boniface Hospital, Dr. Allan Erwin Diner, 78, passed away peacefully with his family at his side ...

Allan attended St. John's High School, the University of Manitoba, and graduated from the University of Toronto Faculty of Dentistry. He served as a Captain in the Canadian Dental Corps. Overseas during the Second World War. Upon his return he practiced Dentistry in Winnipeg for over 45 years. He taught at the University of Manitoba Faculty of Dentistry from 1967 to 1987...

Donations in Allan's memory may be made to St. Boniface Hospital Research Foundation Age of Discovery Fund or Studio Programs at the Winnipeg Art Gallery.

Daddy, we love you and miss you! Don't take any wooden nickels!!

◻ ◻ ◻ ◻ ◻

These first two memorable experiences with public art are effectively conceptual bookends in my imagination. What two more completely divergent representational strategies could I have happened upon? The epitome of the kitsch

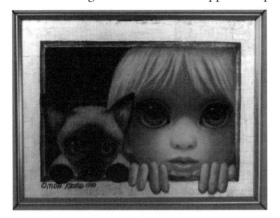

experience, Keane's big-eyed children countered by a slab of high-modern, minimal, colour-field abstraction. I am speculating that Dr. Diner's waiting room painting was an evocation of formalist aspirations that appeared in the twentieth century, culminating in art critic Clement Greenberg's writings. I can do little more to explain the thoughts I project on this painting than art theorist Wilhelm Worringer, who in 1910 proposed:

Silver Blue Eyes *by Margaret Keane, 8 x 10 original oil on masonite, 1989. Courtesy Keane Eyes Gallery.*

The simple line and its development in purely geometrical regularity was bound to offer the greatest possibility of happiness to the man disquieted by the obscurity and entanglement of phenomena. For here the last trace of connection with, and dependence on, life has been effaced, here the highest absolute form, the purest abstraction has been achieved; here is law, here is necessity, while everywhere else the caprice of the organic prevails. But such abstraction does not make use of any natural object as a model.[2]

Worringer's statement puts forward a desire for transcendence from an imperfect world. The entanglement of phenomena, the lack of order and clarity in the fragmentary and contingent, and the entropy of the organic body are thought undesirable compared to the objective, noncapricious order of abstract law. Worringer's flight from the body aims at "overcoming," escaping into an ordered, nonorganic universe.

In a world of abscessed teeth, flesh-eating bacteria, AIDS, and brain damage, I can understand this desire. It's a utopian gesture, a flight from weakness.

□ □ □ □ □

Clement Greenberg's reason for seeking transcendence is the most compelling aspect of his writing. Greenberg sought in the formal anonymity of the non-representational an escape from the holocausts of the twentieth century. Writing in 1939, he was prescient. Greenberg's writing on kitsch sprang from his fear of its "virulence." He feared that this "inferior," mass-produced material was available to the fascists for manipulation of the masses, and that "the main trouble with avant-garde art and literature, from the point of view of fascists and Stalinists, is not that they are too critical, but that they are too 'innocent.'" He claims, "It is too difficult to inject effective propaganda into [art and literature], that kitsch is more pliable to this end."[3]

Greenberg sought out the peace and certitude of the nonrepresentational for solace in an uncertain and inassimilable world, calling on the "innocence" — a childlike attribution — of high art. That Greenberg sought transcendence from suffering through "innocent" high art resonates with the comparable disavowal of suffering in Keane's depictions of "innocent" children.

The big-eyed children, despite their vulnerability, demand our attention. Psychoanalyst Judith Vida states:

> These [Keane's] paintings can be construed both as giving witness to an encrypted layer of universal suffering and at the same time contributing to a universal disavowal of that suffering. For that flicker of an instant we can glimpse the uneasy relation between presence and absence, between the living and the dead, between the smallness of the person in the present and the pressure of a vast unfathomable past. "Kitsch" is what we call it when we belittle with contempt that which frightens us, that which unnerves us for our utter inability to contain its contradictions. There is a gap between the larger social purpose for which World War II was fought and the millions of individual lives sacrificed or deformed to attain that purpose. "Those eyes" of Margaret Keane looked into that gap, and then they, too, became as frightened as the rest of us to go on looking.[4]

I have no preference for either of these subjects of Greenbergian analysis, the high modern or kitsch. For Greenberg, abstraction was thought to be universal and transcendent. Yet countless cultural theorists of the late twentieth century have shown how these claims to universality and transcendence tend to erase cultural

difference, or that the so-called universal means the white European male. Mass culture, conversely, can be the embodiment of complex cultural meaning (for example, *The Simpsons*). Today, arguments about high versus low art have largely lost coherent meaning, with culture becoming an ooze of nebulous references and significances.

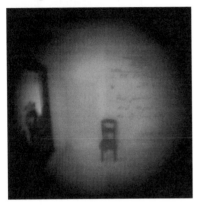

Edward Poitras, The Waiting Room, 1998, wood, plastic, paper, mixed media, 23.5 x 20.8 x 24.9 cm. From the exhibition, Little Worlds. Courtesy the collection of the Regina Public Library.

□ □ □ □ □

The medical establishments of my childhood were unintended classrooms for contemporary art theory and history. My formative art experiences were also experiences in healing. The term *curator* is derived from the Greek "to care for" those objects and documents in a collection. This medical derivation of curating echoes the curative setting of my personal initiation into art.

Adding strength to my association of empathy and caring with curating is a passage I stumbled across, a description that strikingly summarizes the parameters of my curatorial practice: "a complicated weave of sociology (tradition, rites), psychology (hand-to-mouth behaviour), politics (poverty), and biologism (manifestation of deficiency). We are in the space where culture and disease overlap."[5] But this description is no passage from a curatorial handbook. Rather, it is a description of the origins of *geophagia*: the act of eating mud.

□ □ □ □ □

I began my curatorial practice as a programme coordinator at the AKA Artist-Run Centre in Saskatoon. *Flower Theory* by Joanne Bristol was among the first exhibitions scheduled when I got there. That's where I met Bristol and began a five-year conversation through art, life, and love about empathy, loss, weakness, and failure.

In a performance at the Western Front in 1995 called *Centre of the Universe*, Joanne showed a video projection of her mom, Marie, as a meteorologist-fortune-teller-Wizard-of-Oz character. Marie's monologue included quotes by Patti Smith ("I don't fuck much with the past, but I fuck plenty with the future"), and the Clash ("The ice age is coming, the sun is zooming in"). These words,

delivered with the matter-of-factness of a weather reporter, suited the meteoro-logical nature of the Clash's apocalyptic lyric, as a swirling satellite view of the world behind Marie's head morphed the weather report into a crystal ball. She was talking beyond science, and like Patti Smith, was getting metaphysical. Marie — with hypnotic suggestion — then delivered the incantation: "*You will become a friend of mud.*" Bristol was talking about how to be in this world. Partly ecological imper-ative, partly an embrace of the abject, her statement is a touch-stone of feminist reinterpretation of nature and desire.

☐ ☐ ☐ ☐ ☐

My curatorial work is based on the immanence of the weak: philosophically, this phrase means a "witnessing" or remembrance of weakness. Socially or econom-ically, the phrase means an

Joanne Bristol, Centre of the Universe, *1995, still from video element of performance. Courtesy Joanne Bristol.*

acknowledgement of the weak. (Heterogeneous capitalist society attempts to make poverty "disappear.") Biologically, the phrase means a responsibility to the weak, the provision of empathy and curative assistance. Psychologically, the phrase recognizes art as a recuperative act.

Becoming a friend of mud implies the development of an intimate relationship with that associated with filth, disease, and disorder. Analogically, it implies more than wallowing in muck. I am too optimistic to revel in abjection as the least compelling of the nineties pathetic aesthetic seemed to do. Rather than embracing an aesthetic shock tactic aimed at abjection, I am interested in art that finds its meaning outside dominance.

Consider that *pathos* means a suffering feeling: the quality in representation that excites a feeling of pity or sadness, stirring tender or melancholy emotion. The prefix *patho* from the Greek means a form of suffering or disease. It is transient or emotional as opposed to permanent or ideal. These qualities are what I love in art. Transience and emotion are counter to everything art has valorized in modernism. Pathos carries within it, immediately, associations of the sick, the diseased, and the unwanted.

So does geophagia:

> Soil eating is poverty and hunger's most extreme outpost. It is an activity that is charged with a strangely archaic quality where a lack is miraculously turned into a surplus. In his febrile state of hunger, the soil eater transforms the bed of the river into filling food. He is set within a hallucinogenic landscape where the very ground he walks on is transformed into nourishment. For science, geophagia is a hard nut to crack. The phenomenon is located at the intersection of sociology, medicine, and religion, and studies of soil eating need a thoroughly interdisciplinary approach.[6]

This act, by turns abject, pathetic, and circumscribed by weakness, is also utopian, inspired, and profoundly creative.

□ □ □ □ □

My curatorial work thus far is not a culturally restorative pursuit, but perhaps it is curative as a practice of associative or investigative research. I have theorized weakness, empathy, pathos, and associated sentiments such as nostalgia as responses to modernism. This metanarrative can be traced through the diverse forms of various curatorial projects. They include *Little Worlds* (1998), an exploration of diminutive environments; *Fluffy* (1999), a laboratory of cuteness; *Beautiful Losers* (1999), a meditation on loss and failure; and *Space Camp 2000: Uncertainty, Speculative Fictions, and Art*, a cocktail of space-related thought that proposed science-fiction narratives as agents of alterity and disruptions of rationalism, that is, as emotional, contingent, suspect.

□ □ □ □ □

The work of Calgary-based artist Luanne Martineau has engaged questions of naturalism and abstraction by denying the assumption that nonrepresentation has removed a stable referent or indexical source. I curated an exhibition of Martineau's work in 2000, in which she presented a world of decomposition and decay. Her quiet works carry an emotional and conceptual weight belied by their slight material forms: slender doodles on transparent paper, transferred to cotton; almost invisible embroidery. Old Gestetner photomechanical reproductions fade almost before the viewer's eyes. Her sculptures, made from a common craft-clay compound, suggest disposable material, waste, soil, and excrement.

(As psychoanalytic theorist Julia Kristeva points out, abjection is not caused by a lack of cleanliness or by ill health, but by that which disturbs identity, system, and order. These phenomena do not respect borders, positions, rules; the in-between, the ambiguous, the composite.)

Martineau's illustrations consist of consumptive prairie landscapes; tenements and ghettos in decay; abstract representations of alien forms sliding into disarray. Piles of organic matter are displayed in museum-like fashion, safely shrouded in covered pedestals. By contrast, the Gestetners are not even presented as finished works, but rather as hypothetical sculptures, unrealized, flaccid, lacking, and tenuous.

More significant than the formal representations of abjection in Martineau's work, are the related observations of breakdown in systems of order and understanding. Martineau's work creates disrupted visual narratives that suggest narrative omission.

Luanne Martineau, Untitled (accumulation sculpture), *2000, craft clay compound, 35.6 x 26.8 x 20 cm. From the exhibition* Saskadiaspora. *Photo by Patricia Holdsworth, courtesy Dunlop Art Gallery.*

Her practice is preoccupied with the absence of functional master narratives, and this absence collapses all but momentary coherence.

❑ ❑ ❑ ❑ ❑

Winnipeg artist Daniel Barrow is developing a new body of work. In a series I will curate, he continues his previous thoughtful evocations of the emotional. His "live illustration" or "manual animation," *Looking for Love in the Hall of Mirrors,* is a narrative performance of drawings on acetate presented on an overhead projector. It relates the musings of a foppish old man who moved from the farm to the city to begin a committed and confused analysis of love and artistic success. The form of Barrow's work — using old-fashioned mechanical appurtenances — represents a disruption of faith in progress. In his new works, Barrow will depict scenes of nostalgic romance in prairie settings. Landscape paintings found in second-hand stores will be detourned with Barrow's embellishments, including scenes of rubbish amid nature.

Friedrich Nietzsche, the author of *Will to Power,* suffered most of his adult life from illness: headaches, insomnia, and near blindness that sometimes drove him to suicidal despair. For Nietzsche, the only truth about the world and about us

is the irrepressible will to power, or our need to control. Humans therefore only create "truths" for themselves that are useful and help them survive as a species. The legacy of Nietzsche, along with Darwin and Freud, has been to create a world of domination: the will to power, the survival of the fittest, the Oedipus complex. I do not propose to celebrate weakness simply as the antithesis of domi-

Daniel Barrow, Looking for Love in the Hall of Mirrors, 2000, digital photograph of projection from performance. Courtesy Daniel Barrow.

nation. My challenge is to present a diversity of artists, artworks, expressive modes, and preoccupations with a meaningful philosophical grounding and curatorial desire based on the question of how to be in this world.

In philosopher Gianni Vattimo's depiction of the postmodern age of nihilism, we are left with weak thinking aimed at a weak and vanishing being. To Vattimo, a world in which there is no ultimate reality, and only multiple interpretations, domination might be less likely to occur. Rather than basing all our hopes on a single utopia, he suggests that we accept a being that repeatedly dissolves. Accordingly, being can no longer be seen as an eternal structure. Rather than those destructive nihilists who believe that being ultimately dissolves into nothingness, Vattimo holds out the possibility of a weak subject. The modern experiment has come to an end, and with it, a faith in progress and emancipation. However, if we accept a reality that is continually dissolving — while less reassuring than the age of myth or the age of reason — we may still hold out hope for an emancipation of a limited kind. In the aftermath of the erosion of faith in a fixed reality, a plurality of world pictures that emerges could lead to the liberation of difference.[7]

I do not want to wallow in the slime of nihilistic despair. I seek a means not of transcending — climbing out of the mud — but rather of practising empathy, moving with care along this field. I want to become a friend of mud.

1 Keane's ex-husband Walter claimed their authorship, a story that there is no space to relate here. Margaret inspired many imitators with fantastic names — Gig, Eve, Lee, Goji, and Franca — one or another of whom may have actually produced the reproductions in Dr. Goldberg's office. For more information on Keane, see Tyler Stallings, ed., *Margaret Keane and Keanabilia* (Laguna Beach: Laguna Art Museum, 2000).

2 Wilhelm Worringer, *Abstraction and Empathy: A Contribution to the Psychology of Style* (Cleveland: World Publishing Company, 1967; 1910), 20.

3 Clement Greenberg, *Clement Greenberg: The Collected Essays and Criticism. Volume I: Perceptions and Judgements 1939–44*, John O'Brian ed. (Chicago: University of Chicago Press, 1986), 20.

4 Judith E. Vida, "'So — What Is It About Those Eyes?' (How Pain Becomes Kitsch)," in Tyler Stallings, ed., *Margaret Keane and Keanabilia* (Laguna Beach: Laguna Art Museum, 2000), 14–15.

5 Magnus Bärtås and Fredrik Ekman, "The Soil Eaters," *Cabinet 3* (New York: Immaterial Incorporated, 2001), 42–43.

6 Magnus Bärtås and Fredrik Ekman, "The Soil Eaters," *Cabinet 3* (New York: Immaterial Incorporated, 2001), 42–43.

7 Gianni Vattimo, *The End of Modernity*, trans. Jon R. Snyder (Baltimore: Johns Hopkins University Press, 1995).

MATTHEW HIGGS is currently the associate director of the CCAC Wattis Institute at the California College of Arts and Crafts in San Francisco. He is also an associate director of exhibitions at the Institute of Contemporary Arts in London, where he recently curated the exhibitions *Sound and Vision,* and *City Racing 1988–1998: a partial account.* A former lecturer at both Goldsmith's College and the Royal College of Art in London, Higgs has contributed articles and essays to numerous exhibition catalogues and journals, including *Artforum* and *Art Monthly.* Since 1993 he has been the publisher of Imprint 93, an ongoing series of artists' multiples and editions.

■

Between the Audience and the Stage

MATTHEW HIGGS

I RECENTLY TURNED THIRTY-SEVEN. For the last fourteen years, I have chosen to live and work in London, England. Before that time, I studied as an artist for three years in Newcastle-upon-Tyne. And before that, I lived in a small market town in the northwest of England called Chorley.

Chorley made me. It defined who I am. In the late 1970s — my youth — Chorley was down on its heels. Chorley had — and probably continues to have — a lack of self-confidence. A predominantly working-class community, Chorley had grown up around the textile mills established in the late Victorian era. By the time Margaret Thatcher came to power in 1979, Chorley's once-proud manufacturing heritage (with its legacy of trade unionism) was already long gone.

My youth was dominated by the spectre of unemployment, by the spectre of Thatcherism. Beyond drinking in a handful of pubs, there was little or nothing to do. I had four close friends, brought together by a shared passion for the then-developing independent music scene that had emerged in the aftermath of punk.

The one thing Chorley had going for it was proximity to Manchester and Liverpool. Those cities would provide me — more than any schooling ever would — with my education. Those not from the northwest of England may find it hard to appreciate the importance of these cities from 1978 to 1981. There existed a skeptical pragmatism, nurtured through years of economic neglect, as

palpable as the grey skies over our heads. From the estranged perspective of Chorley, the London of the Sex Pistols and The Clash — the London of 1976 and 1977 — was a foreign land. (At that time, I didn't know anyone who had even been to London.) Manchester in the late 1970s was the home to Joy Division, The Fall, and Factory Records; Liverpool, the home to Echo and the Bunny-

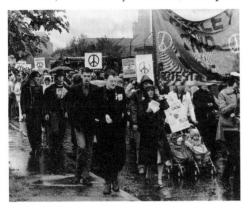

Campaign for Nuclear Disarmament (CND) March, Chorley c. 1980. Matthew Higgs, centre, wearing glasses. Courtesy Matthew Higgs.

men, The Teardrop Explodes, and Eric's nightclub.

I ultimately became interested in art through an interest in music. Obscure references on record sleeves prompted my curiosity for the Situationist Internationale, the Dadaist milieu of the Cabaret Voltaire, and the twisted literature of William Burroughs and other avant-gardes. In 1979, at the age of fourteen, I started a fanzine. Inspired by the proliferation of independent publishing, and fuelled solely by teenage enthusiasm, my fanzine was to provide me with a line of communication that went beyond Chorley's claustrophobic limitations. Despite the fanzine's modest circulation, I soon found myself implicated in an informal network of like-minded correspondents from across Britain, Europe, and eventually the United States and beyond. It was a community of sorts, certainly the first I had encountered outside of my immediate circle. Aged fourteen, my world suddenly got larger.

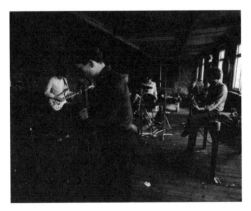

Joy Division, Manchester, 1978. Matthew Higgs, age 13, at rear, third from left. Photograph by Kevin Cummins.

Today, when I am asked to talk about my practice as a curator, writer, publisher, and (sometimes) artist, I always refer back to this time. For me, it is important

to publicly acknowledge how and why I became involved in working with artists. There is no consensus as to the role of the curator, just as there is no single definition of what constitutes art. In struggling toward rationalizing my own practice, the closest I have come is in the possibility and potentiality of working between the audience and the stage. The reference to a "live" context is as intentional as it is explicit. All exhibitions — whatever form they might take — are events, ultimately dependent on their relationship with an audience, with a lived experience. My experience as a teenager — in fact, the reason I started to write, publish, and distribute my fanzine — was borne out of a frustration with the traditionally passive role consigned to the audience. At the same time, I had no personal desire to perform on the stage. (I would have made a lousy musician.) Between the audience and the stage, between the spectacle and its reception, there exists a "space," a tangible if undefinable space in which to operate. It is this space that interests me, and it is this space that I continue to negotiate. I have always enjoyed organizing things. While publishing my fanzine, I would organize gigs in my hometown. (New Order's first publicly advertised gig in January 1981 was my crowning moment.)

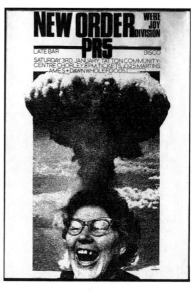

Poster designed by Matthew Higgs for New Order's first advertised concert. January 3, 1981, Chorley. Courtesy Matthew Higgs.

Later, while studying art in the mid-1980s, I started a nightclub in Newcastle with a friend from art school. Each of these endeavours was borne out of a necessity, a desire to make something happen. To fill a void. To alleviate boredom. To make life more interesting. My involvement with art, and with developing projects with artists, emerges from exactly these same desires.

◻ ◻ ◻ ◻ ◻

I'm interested in gaps, in the spaces and situations that are neglected or overlooked for one reason or another. The monolithic institutions, with their accordant bureaucracies, hold no fascination. If nothing else, they are too unyielding, seemingly unable to act responsively. In 1993, after a six-year, self-reflexively inactive period, I initiated a publishing project called Imprint 93, which was

indebted as much to the do-it-yourself aesthetics and strategies of fanzine culture as to the earlier methodologies of, say, Fluxus or the Mail Art movement of the 1970s. Imprint 93 was a vehicle, an agency, through which I could both commission and distribute artists' projects. Despite being its sole proprietor, I consider this project as and remaining essentially a collaborative act — an

accumulative project: the sum of its parts. Its motto was "Imprint 93 celebrates other people's ideas." Realistic in its ambition, Imprint 93 operated on a minuscule budget, supported for many years by my income from a part-time administrative job in an advertising agency. It was an attempt to rationalize my ongoing interest

Imprint 93, various projects. 1993–1997. Courtesy Imprint 93.

in contemporary art while negotiating the everyday practicalities of living and working within a specific context, namely London in the early 1990s.

The "local" is often depicted pejoratively, aligned with nationalistic tendencies. I don't subscribe to this view of the local. A sense of locality and an acknowledgement of the responsibilities (and limitations) that go with working within a particular community are at the centre of my practice. An acknowledgement of the specificity of a particular context and how its particular (and peculiar) nuance affects individuals and cultural production continue to motivate me.

Much has been written about the London art scene of the 1990s. Mythologized through the acronym "yBa" (young British art/artists), the real story of British art's passage through the 1990s has yet to be written. Contrary to received history, there existed a spirit of adventure and exchange. Despite often-conflicting interests, a genuine sense of dialogue existed. Artist-run spaces, artist-led initiatives, artists' collectives, collaborative projects, and individualistic gestures proliferated. Each in their own way struggled toward a redefinition, a re-examination, a reconsideration of what constituted a public threshold for the presentation and dissemination of art. The scene was, in the best sense of the word, amateurish, run largely by enthusiasts. Improvisatory and ad hoc, it survived and thrived outside any commercial imperatives. It also affected my publishing project.

Distributed by mail and free of charge, Imprint 93 has published some sixty projects to date. Its flexible form allows it to represent my often catholic tastes in art. At one extreme, it includes the brutal and often maudlin poetry of punk musician Billy Childish, and at the other extreme, it takes in the tragicomic conceptualism of Martin Creed. Imprint 93 operates in the manner of both a parasite and a virus: parasitical in its realistic awareness of its dependency on the art world for legitimacy, and viral in its unannounced, unsolicited arrival from an ostensibly anonymous source. In the early 1990s, few, if any, people in London were publishing and distributing new work by artists in this way. Imprint 93, by default, had the territory to itself. It distinguished itself through a lack of alternatives. Imprint 93 gave me the opportunity to collaborate with a generation of artists, of a roughly similar age, at an early stage in their practices, establishing working relationships that persist. This sense of continuum, of a dialogue that goes beyond a particular project or event, is critical to my practice as a curator.

□ □ □ □ □

Over the last ten years, I have realized some hundred projects with artists, either independently or through public or private organizations. From the outset, each project is determined by the specifics of its context. Curating each project remains a largely intuitive act. My job — if it is a job — is to establish an appropriate response to each situation. Consequently, each project is different — determinedly so — and demands a distinct rationale. Of course, this claim might sound like stating the obvious, but the reality is that most exhibitions are still instigated, administered, realized, and received according to models established decades ago, and those models are increasingly inappropriate to current artistic production. This consensus or status quo has increasingly led to the homogenization of exhibition culture, a culture that aspires to a kind of visual Esperanto, the results of which are invariably empty spectacles drained of any specific nuance, inflection, or dialect.

In 2000, the British Artists Collective Bank imagined a scenario in which all of the publicly funded galleries in London would be forcibly closed down. In turn, Bank proposed taking all the money from "those curators & statusmongers & bureaucrats & moneymen & managers."[1] According to Bank's vision, the money would then be redistributed:

> to ARTISTS, who would set up loads of temporary, more
> exciting spaces for lots of artists to show in. There'd be
> much more art around because the money would go so

much further than it does now as it wouldn't be spent
fuelling the careers of all those who pretend to be the
friends of artists but are really their lazy, powerful enemies
...JUST IMAGINE ALL THAT ART! It would make
London a phoenix reborn from the ashes of bureaucracy!!
LET'S DO IT!!![2]

This might seem a little dramatic, but I can sympathize with Bank's position.
(Indeed, why restrict it to London?) The contemporary art world is too profes-
sional. The increasingly bureaucratized role of the curator should — as Bank
identified — be the cause of some concern. Curators do not initiate shifts in
culture; at best they can respond to the new directives initiated by artists. The
artist should be privileged at all costs.

▢ ▢ ▢ ▢ ▢

Artists are among the last great amateurs. My dictionary locates the origin of the
word *amateur* in the Latin term for lover. Nowadays, the amateur is a maligned
figure, with the word often little more than a shorthand for contemptible
ineptitude. But in our increasingly professional and bureaucratic art world, we
should learn to cherish the amateur, to celebrate those rare individuals motivated
by enthusiasm and love. From the inspired Victorian philanthropist Sir John
Soane, whose incredible museum in central London remains unburdened by
the typical hierarchical notions of value and taste, to the recent projects of the
British artist Jeremy Deller, the spirit of the amateur is alive and well. A trained
art historian, Jeremy Deller is one of the most compelling artists working today.

Deller operates (loosely) within the relatively recent trajectory of the artist-
curator: a slippery coalition, whose numbers would include such seminal figures
as Marcel Duchamp, Marcel Broodthaers, and Claes Oldenburg. Deller's ongoing
project proposes a radical reappraisal of conventional assumptions about both
artistic and curatorial practice. *Unconvention* (1999/2000) — although not
typical — is illustrative of Deller's approach. Essentially a group show, for which
I wrote the catalogue's introductory text, *Unconvention* was devised specifically
for the short-lived Centre for Visual Arts in Cardiff, South Wales. *Unconvention*
emerged from an earlier Deller project, *The Uses of Literacy* (1997).

The Uses of Literacy was a display of artifacts — drawings, paintings, poetry, and
prose — produced by fans in response to the historical and cultural interests and
obsessions of the Welsh rock group the Manic Street Preachers. It is described by
one of its participants as "a poetic record — seen through often extraordinary
images — of the screams, sighs and whispers of some remarkable young people."[3]

The Uses of Literacy encapsulated and prioritized the latent creativity of its teenaged authors. The Manic Street Preachers, more than any other British band, have continually sought to contextualize their intentions through references to other artists and writers. For their fans, the band has, in turn, become a kind of parallel education: providing them with access to images and literature denied or suppressed by conventional schooling. Rejecting conventional curatorial wisdom, Deller assembled an exhibition from the viewpoint of a rock band, rather than from an art historical, theoretical, or nationalistic perspective.

The resulting exhibition provoked visual juxtapositions as unlikely as they were profound: key works by Lawrence Weiner, Andy Warhol, Francis Bacon, Edvard Munch, Martin Kippenberger, Pablo Picasso, and Jenny Saville were displayed next to documentary war photographs by Robert Capa, Kevin Carter, and Don McCullin. Archival sections devoted to the Welsh miners' fraternal involvement in the Spanish Civil War sat alongside the complete literature of the Situationist Internationale. For the exhibition's opening weekend, Deller invited numerous local organizations — from Amnesty International and the Campaign Against the Arms Trade to fanzines produced by fans of the band — to set up stalls amid the artworks. Reminiscent of a (radicalized) village fete, the opening weekend's events concluded with an impassioned speech by Arthur Scargill — president of the National Union of Mineworkers — and a stirring performance by the Pendyrus Male Choir, singing songs of passion and resistance originally sung in the mining communities of South Wales. Each artwork, each organization, each document, each individual was accorded an emotional and intellectual equality. The usual distinctions between high and low cultural artifacts were abolished.

Unconvention was the most context-specific artwork I have encountered. It engaged explicitly and unashamedly with the social, cultural, and political legacies of its constituents — the people of South Wales — mediated through

Jeremy Deller, Unconvention, *1999–2000, Cardiff Centre for Visual Arts, the Pendyrus Male Choir/Andy Warhol. Courtesy Jeremy Deller.*

the agency of a local contemporary rock band who, since its inception, sought to address the discrepancies and injustices in society. That some four thousand people attended its opening weekend made it all the more remarkable, not only validating Deller's enterprise but vindicating his persistent belief that art does not and cannot exist in isolation. Jeremy Deller operates as a catalyst. Working literally between the audience and the stage, Deller's art is one of democratization: it demystifies and liberates the construction of meaning, empowering both its audience and its participants. Ultimately *Unconvention* consolidated my persistent belief that art does have the potential both to illuminate and to transform our experience and expectations of life, without patronizing its audience. The exhibition reinforced the necessity for self-determination that I had encountered as a teenager in the independent music scene of the late 1970s. In amplifying and privileging mutuality, Deller served to remind us that only together can we confront and challenge orthodoxy and that together we must accept responsibility for our destiny. Or as The Pop Group once said, "Where there is a will, there has got to be a way."

1 Bank, "Just Imagine," *Art For All?* (London: Peer, 2000), 22-23.

2 Ibid.

3 Marc Casnewyd, in Jeremy Deller, *The Uses of Literacy* (London: Book Works, 1999).

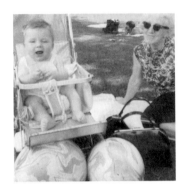

ANDREW HUNTER is an independent artist, writer, and curator based in Dundas, Ontario. He has produced publications and installations for art galleries across Canada and in the United States. *Billy's Vision* was produced for the Mendel Art Gallery and toured to the Dunlop Art Gallery, Walter Phillips Gallery, and National Gallery of Canada. He has held curatorial positions at the Art Gallery of Hamilton, Vancouver Art Gallery, and Kamloops Art Gallery.

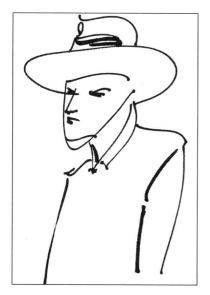

Cliff Eyland, Billy #1, ink on file card, 1998.
Courtesy Cliff Eyland.

□

Speaking of Billy

ANDREW HUNTER

Fathers and Mothers
Sons and daughters too.
Gather 'round good people
I've a story to tell you.
It's the tale of Drifter Billy
That is known to but a few.
But be forewarned.
Not all of what I tell you
May be true. — Cowboy Luke

I THOUGHT I SHOULD START where my exhibition, *Billy's Vision,* begins, with these words and Cliff Eyland's drawing.[1] Cliff's drawing is based on a character that came to me in a story my Grampa told me when I was a kid about a rather unusual individual named Billy. I told the story to Cliff, and this image was his response, his "idea" of the character based on my narrative. I didn't tell him what to draw, or what Billy should look like; I just told him a simple version of the tale. Later, Cliff produced another, very different version of Billy.

This is how Billy has evolved. Stories are told, people respond, make things, and so the story is passed on. With each telling, the story changes, accumulating elements of previous versions and being embellished by the teller. Billy could

be an angel, an alien, a demon, a freak, a lost soul, or just a man. Is he real? I'm not sure. He's been around long enough that he sure seems real to me.

I asked my Mom once if Grampa had ever told her the Billy story. She said she couldn't recall hearing the story, but she did remember an old photograph that Grampa had had at the house of a man and two boys running to a shack in a dust storm. She said that the Billy I described from Grampa's story sure sounded like the guy in the picture. The picture looked something like this.

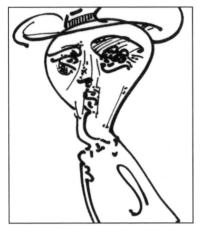

Cliff Eyland, Billy #2, ink on file card, 1998. Courtesy Cliff Eyland.

I remember seeing this picture in the back bedroom of Grampa's mobile home at Eagle's Landing near Chippewa Creek. Just before he died, Grampa burned it along with almost all of his photographs. He took all these peach baskets full of photographs out behind the barn, near the big old elm tree, and torched them. The only picture he kept was a little framed photo of his first son who had died when he was only six years old. So this picture isn't "the" picture; it's an idea of the picture. It's what I remember it looking like. You see, that's what most of my work is about: making things that are an idea of what I, or others, remember. That's what my exhibition *Billy's Vision* is. Memories made physical based on stories people tell.

I asked Mom about the stories Grampa used to tell. I asked her, just like people always ask me now, "Are those stories true?" She said: "Your Grampa was a great guy, I mean, he was a very pleasant person, but if you listened to his stories as often as I did, you could see variations in them. He had certain types of characters he'd repeat in his stories, and certain details that kept popping up too. There were always mysterious figures in his stories and people that seemed to appear and disappear. He used to always start his stories by saying, 'I'll tell you a story, I'll tell you no lies.' But I don't think all of what he told you may be true."

Mom says I'm a lot like Grampa.

It's funny, I'd forgotten about his way of starting a story until Mom said it. "I'll tell you a story, I'll tell you no lies." That's a pretty standard beginning to a traditional folk song. It's sort of a "Come all ye," an announcement by singers that they are about to relate a tale. Grampa liked music, but I don't remember him listening to old-time folk music. The Lawrence Welk show is all I can remember about him and music.

What got me thinking again about Billy were two things: a "vision" I had while driving across the Canadian prairie, and something my daughter Maggie said to me when I got to my final destination on that trip. Most of my ideas come to me when I'm driving or just walking around. I've admitted this fact on several occasions: my work largely consists of wandering around and waiting for things to happen. I look at the arrange-ment of things in people's gardens, the painting and decorating of houses, the dialogue between old and new buildings, forgotten spaces like the edge of building lots, old playgrounds, and parks. I look at common and/or traditional nar-rative forms — quilts, billboards, memorials, and cemeteries. And I listen to people, anywhere, whether I know them or not. People say the most interesting stuff.

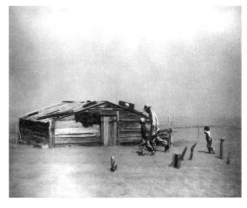

Billy in a dust storm, after Arthur Rothstein, c.1935. Image courtesy Andrew Hunter.

So, back in 1998, I was driving across Saskatchewan heading for Saskatoon to meet with Gilles Hébert and Dan Ring about doing a show for the Mendel Art Gallery.[2] It was getting late. The sun was going down and it was cold. There was snow. Not too much, but enough to make little waves across the fields and drifts against buildings. I was looking out across such a field when this old, rundown shack, partially buried by blowing snow, passed before me. That old photograph from Grampa's came to me in a flash.

When I got to the Mendel the next day, Gilles asked me what kind of a show I wanted to do. I said, "Well, I just had this vision out on the prairie that looked a lot like this photograph Grampa used to have. There was a guy in the photo, a tall man with kind of long arms, and I've always wondered who he was and where he'd come from. I think he was from around here. I'd like to tell his story."

Look for signs. That's my curatorial motto. Keep your eyes and mind open. The messages are out there just waiting to be seen and heard. (I'm not talking about some *X-Files* thing; people are always mentioning that TV show in con-nection to my work. I have no interest in all the conspiracy baggage that goes with that show. I'm interested in smaller, more personal tales.) So after Gilles says we can go ahead and do the exhibition, I head out for Winnipeg, which was my final destination. I'm thinking about Billy, and the more I think about him, the more uncomfortable I start to feel. I'm getting edgy and irritable. Then, just as I'm crossing into Manitoba, I start to feel really sick. I just manage to pull off

the highway, but before I can reach the plastic bag on the floor, I puke. I don't mean a little spit-up like a baby will do. I retch all over the front seat.

Every vehicle that passes shakes the car. I'm right on the edge of the road, having barely made it onto the gravel shoulder. I'm just sitting there, like the big fat guy in Monty Python's *The Meaning of Life* who foolishly ate "one

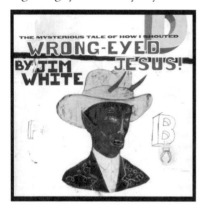

wafer-thin mint." I'm thinking, "What did I eat that would have caused that?" And then I remembered something Grampa told me one night after I'd had a bad dream. He said, "Sometimes in this life you are going to encounter people and they'll change you and your memory of them is going to affect you physically. Some people don't want to be forgotten. They are going to claw their way back into your memory."

Jim White, Wrong-Eyed Jesus!
Luaka Bop Records, 1997.

I barely made it to Winnipeg. I arrived late at night. Maggie was asleep and Lisa was sitting in the dimly lit front room among piles of unpacked moving boxes reading the paper. I collapsed on the bedroom floor. Maggie woke me in the morning, and I seemed to have recovered from my trip. We went for a short walk down by an old hockey rink near the Red River. Standing on the shore, looking across to St. Boniface, Maggie told me, "I used to be a tall man with long arms."

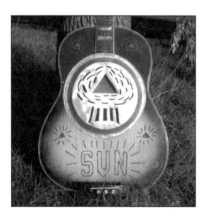

Billy's guitar. Image courtesy
Andrew Hunter.

So I started thinking about Billy and trying to recall the details of the story Grampa had told me. He'd said he'd "encountered" Billy when he was in Saskatchewan during the 1930s. He said he'd been collecting stories from farmers about their experiences with the drought and bad weather, and that that's when he first saw Billy, on an old farm near St. Laurent, north of Saskatoon, near a Catholic shrine. The shrine had been built where people had had visions of the Virgin Mary hovering above the Saskatchewan River. According to Grampa, Billy had visions too, but not of the Virgin. Grampa talked to other people who had met Billy. Some said he was

sick, some said he was an angel, and others thought he was evil, but they all agreed he was strange looking. Those who thought he was evil said that he'd brought the bad weather and the plague of grasshoppers, and they claimed he had skin like an insect. They said he used to wear this white hat all the time and a suit with long arms. Wandering through the HMV store in downtown Winnipeg one day, I spotted this face on a CD, sitting out of place on a shelf of videos. It was as if someone had just placed it there for me to stumble on. Whenever I think about the evil Billy, I see this face.

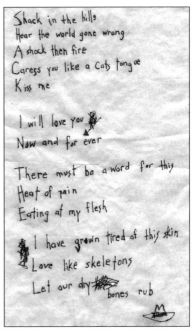

But Grampa said that to most people, Billy wasn't sinister, though he still looked funny. This guy named Cowboy Luke seemed to like Billy. He was an itinerant musician who travelled around singing and playing his guitar. He wore a white suit and hat and played a Dobro guitar. He said that Billy had visions and wanted to share them with people and that he kind of modelled himself after Cowboy Luke. Billy would wear a white suit too, and he even made himself some instruments, but instead of the roses and horses Luke had on his suit and guitar, Billy pictured his visions. Triangles, rays of light, and mushroom clouds; they were embroidered on his suit, and they

Fragment of poem by Billy. Image courtesy Andrew Hunter.

decorated his guitar and mandolin. These images were burned, painted, carved, and cut out of metal.

Billy decorated the inside of his shack too, "like a church, a real shrine." Grampa told me Cowboy Luke said, "The walls, they was covered with all these little pictures, crosses and clouds and triangles, all kinds of triangles all over the place. When you sat inside with him, Billy would just point at all these pictures and say, 'I saw this. I saw this. I saw this.' Over and over as he'd point 'round the room."

Billy wanted to spread the word, so he wrote songs and tried to sing them to people like Cowboy Luke did. He'd scratch out his lyrics on bits of paper.

Grampa said that Billy's visions were of the atomic bomb, and that just before the Trinity test at Alamogordo in 1945, Billy left Saskatchewan and headed down to New Mexico.

So that's the story in a nutshell, and it's about as much detail as I gave to Cliff before he produced the two drawings of Billy. There's a lot more to the story and more voices that have come into Billy's tale, but that story is told in the exhibition and the accompanying book. There sure isn't room for it all here.

This is what the installation at the Walter Phillips Gallery looked like. It includes

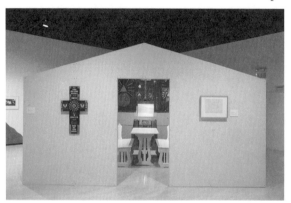

the Billy artifacts (his suit, hat, guitar, mandolin, and chair), an idea of his shack, and documentary photographs. I produce and collect most of the material exhibited in my projects, and I also work with the collections of the museums where I'm exhibiting. What I draw from collections are primarily historical works, and these works can serve to either inspire or set the stage for the narrative. In this case, the works from the Mendel collection give a sense of the Saskatchewan prairie during Billy's time. I try to use the language of the museum to tell my tales. The period room, artifacts in cases, the white cube and grid display of modernism, these settings are some of

Billy's Vision, *Walter Phillips Gallery, March, 2000. Courtesy Walter Phillips Gallery.*

my favourite presentation models, and they show up in most of my projects.

I also commission people to make things based on the narrative I'm developing. I do this because I want to see where a story or character will go when out of my hands. That's why I told Cliff the story, and then told Sarah Abbott, Bill Eakin, Jan Wade, and the Reverend Luke Murphy, who all made works in memory of Billy. Then I told the story to mcenroe, and he created the soundtrack that plays in Billy's shack. It is available with the exhibition booklet, which is definitely not a catalogue. I don't do catalogues for my projects, because I see the publication

as another format for storytelling. I approach the design and creation of the publication with the goal of making an interesting object that will best convey the narrative. I make pulp novels and picture books. Because of mcenroe's soundtrack, making a CD booklet made the most sense for *Billy's Vision*.

When asking me about the show, people often refer to mcenroe as a sound artist who produced a hip hop-like soundtrack. Actually, mcenroe is a hip-hop musician and producer I met in Vancouver through Dave Bidini of The Rheostatics. He was based in Winnipeg when we worked together and is now living in Vancouver, where he produces under the label Peanuts & Corn Records. The way we worked on the Billy sound-track was straightforward: I told him the story, and then he went off and made the CD. Like I said, I like to see what will happen when a story leaves my hands and then deal with the response and be informed by it. Sometimes, this dialogue is formally arranged, as it was with mcenroe or Cliff, but it's often spontaneous. People see the installation or read the book and then offer back connections. I'm told stories about beings like Billy seen on the prairie, such as Nancy Hébert's tale of the ghost of the long-armed cowboy who would appear at the foot of the bed. Or the eerie image Arthur Smith painted of his son "Billie" a year after the boy drowned. Dan Ring found it in Regina a few months before the exhibition opened. It was painted in 1935,

Arthur Smith, "Billie," oil on canvas, c.1935. Image courtesy Andrew Hunter.

the year my Grampa said he encountered Billy. Grampa used to say, "If you tell a story, you'd better be prepared for it to come back to you."

"Does the *public* get it?" "How do you feel about duping and misleading the *public*?" These questions inevitably come up whenever I'm speaking to my professional "colleagues," curators, educators, and faculty of art history, museum studies, and fine art. I have found that members of the public are more sophisticated in their ability to decide for themselves the "authenticity" of my work and to go with it than many museum professionals give them credit for. Some people think the story is true, others think it's pure fiction, but most figure it's somewhere in-between, in that ambiguous grey area where I live. I'm not an academic, and I don't see curatorial work as some kind of objective

science or truth-revealing enterprise. I am a teller of tales, a spinner of yarns, as many curators are, though few seem willing to admit it. No matter how objective you think you are, you make choices about what to talk about and what to exhibit, and that is a very selective and subjective activity.

But I don't want to go down that path of critiquing curatorial practice. That's

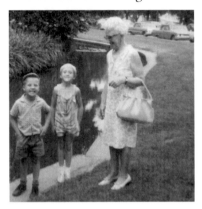

not what my work is about, and at heart I think it is too narrow a focus. Recently, a critic asked me about my work in relation to Foucault's *Archeology of Knowledge*, and I thought, "Well, I read it at school and it certainly influenced my thinking then. But that was an academic environment and that's not my world anymore. I'd say books like *Winnie-the-Pooh* and *Alice in Wonderland* have a much stronger influence on my work now." I'm interested in a much broader audience. I have to be, because the gallery/ museum audience is diverse, and I don't think the majority of people visiting

Me and Sue and Gramma at the park, Hamilton, Ontario, 1968. Courtesy Andrew Hunter.

museums are concerned about theoretical museum issues. I've been criticized for being populist. I can live with the label. Those are my roots.

I've told this story before when asked about my work, and I'm going to tell it again. This is Marion Crawford Hunter, my gramma. She was born in Glasgow and came to Canada after the First World War. She settled in Hamilton in a working-class neighbourhood that was very different from the dark old tenement neighbourhood she left behind in Scotland. But while the area she'd lived in in Glasgow was bleak, it was near a big park and across from the park was a museum. The People's Palace. Built in the early nineteenth century, it was one of the first museums dedicated to working people's history. As a little girl, Gramma visited there often.

When I was little, Gramma took me to museums. Often we went to the old Art Gallery of Hamilton when it was in the west end on the McMaster University grounds. Holding hands, we would wander the galleries looking at the works. I don't remember any "extended labels" or text panels, just rooms of paintings and sculptures. When something caught our interest, we'd stop. "Can you tell me a story?" she'd ask. I would, and now I can't stop.

The last time I saw Gramma, she was in a nursing home. I was with my sister Sue, and we sat by Gramma's bed holding her hand. She started to cry. I was

frightened, speechless. Sue talked to her about her house, the garden out back, the peach trees, and this talk seemed to calm her down. She was quiet, and then, just as we were leaving, she said, "I want to go home."

Remember what my Grampa said about telling stories and how things come back to you? And how he also said that some people "don't want to be forgotten"? Well, he also told me something else. He said, "Sometimes, when people die, they're not finished their journey home, and if you know this, you have a responsibility to help them complete it. They are your baggage. You have to carry them with you through this life, and if you can't get them home, you have to make sure they are passed on to someone else and that they are looked after." This is why Grampa told me about Billy and why I keep telling stories. I keep telling stories for Gramma and to make sure I don't forget.

1 Cliff Eyland is an artist, writer, and independent curator based in Winnipeg, Manitoba.

2 Gilles Hébert is the director of the Mendel Art Gallery, and Dan Ring is that institution's senior curator.

ADRIANO PEDROSA (Rio de Janeiro, 1965) is an artist, curator, writer, and editor who has published in *Artforum* (New York), *Art Nexus* (Bogota), *Art+Text* (Sydney), *Flash Art* (Milan), *Frieze* (London), *Lapiz* (Madrid), and *Poliester* (Mexico City), among others. He was adjunct curator and publications editor of the XXIV Bienal de São Paulo (1998), and he cocurated *F[r]icciones* with Ivo Mesquita at the Museo Reina Sofia, Madrid (2000–01). He is the curator of Museu de Arte da Pampulha, Belo Horizonte, of Programa Arte Viva Brasil, Rio de Janeiro, and senior editor of *TRANS>arts.cultures.media* (New York and São Paulo). He divides his time among Belo Horizonte, Rio de Janeiro, and São Paulo.

Truth, Fiction
(Favorite Game)
[Attrib.]

CATHERINE THOMAS INTERVIEWS
ADRIANO PEDROSA

Truth, Fiction (Favorite Game)
[Attrib.], *ink on paper, 21 x 13.5 cm,
from the collection of the Família
Bezerra Dias. Courtesy Leonilson,
1957 Fortaleza – 1993 São Paulo.
Photograph by Rômulo Fialdini.*

The following interview took place by e-mail from August through October 2001.

CATHERINE THOMAS: You have a very diverse educational background, as well as being a practising artist, writer, and editor. Could you speak about your formation, and how you see all your interests and studies informing your curatorial work?

ADRIANO PEDROSA: This diverse education would probably be regarded as detrimental or unfocused in other professions, yet in contemporary exhibition making is very useful. Since my undergraduate studies, I have been interested in different disciplines. I studied law at the State University in Rio de Janeiro and economics at the Catholic University, where I took classes in other departments such as sociology, philosophy, history, and literature. After graduating in law, I did a year of graduate studies in international relations while I was taking courses at Rio de Janeiro's School of Visual Arts. Because of my interest in theory and language, I immediately became interested in conceptual art. With that in mind, I went to CalArts for its MFA program, with a scholarship from the Brazilian Ministry of Education, and again became interested in other disciplines, studying film, graphic design, fashion, queer theory, literature, even dance. Afterwards, I went to UCLA's

comparative literature program, which houses interdisciplinary studies in the humanities. However, as a writer and artist, I did not function too well in American Academia. In 1997, I had an exceptional opportunity to leave UCLA when Paulo Herkenhoff invited me to work as an adjunct curator at the Bienal de São Paulo. My real training as a curator, like many curators in São Paulo in fact, was at the Bienal, first with Paulo and later with Ivo Mesquita. I must say that I am very fortunate to have always worked closely with the two of them. In the end, it is curious that the only thing I did not study formally was curatorial studies and art history. I am rather skeptical of these curatorial studies programs and believe that a more long-term interdisciplinary formation is more interesting. For me, even law, management, and accounting come in handy when discussing contracts or working in projects with somewhat precarious budgets and structures, something common in Brazil.

CT: Yes, I think it is important to note that the role of the curator often extends beyond exhibition making and requires a great deal of practical — maybe even entrepreneurial — skills.

AP: The curator has been increasingly called to perform many roles, working as an agent negotiating between and bridging different interlocutors, institutes, and levels — a middleperson or a broker, as Mari Carmen Ramirez has put it. On the other hand, beyond tasks and roles, another level is related not so much to negotiation or administration, but to knowledge itself. I'm referring to a certain kind of contemporary curatorial practice associated with what we call *projects*, for the lack of a better denomination, and which go beyond mere exhibitions. These days, an exhibition rarely occurs on its own, as a simple display of objects in a gallery. Talks, conferences, and publications have become a norm. These projects articulate an even wider and more diverse range of activities or events beyond the exhibition, such as screenings, performances, and other special events specifically developed according to the concepts and themes of the exhibition. The exhibition itself in some extreme cases appears not to be the central part of the project. This reflects a desire to establish a more active, dynamic, and multifaceted relationship with artists, intellectuals, institutions, and the public, paired with an understanding that art must be contextualized beyond the white cube, understood and integrated within the culture at large, or the site where it is exhibited, initiated, or produced.

For this reason, we see a number of exhibitions taking an increasing interdisciplinary and an *extra-muros* approach, as we called it in the XXV Bienal de São Paulo, with events dispersed through time, space, disciplines, and fields. Projects such as Hans Ulrich Obrist and Barbara Vanderlinden's *Laboratorium* (Antwerp, 1999), Jens Hoffmann's and Vanderlinden's *Indiscipline* (Brussels, 2001), and Okwui Enwezor's *Documenta 11* (Kassel, 2002), are following these paths. This approach is something we were also exploring in the project developed for the XXV Bienal, under Ivo Mesquita's direction.[1] In these projects, the curator becomes a catalyst, reaching for different specialists or institutions as collaborators. They are often organized by a team composed of curators as well as intellectuals from other disciplines. This approach is different from the traditional curator or conservator, a scholar in specific periods, schools, styles, territories, media, genres, or artists. The more ambitious projects, which are the most interesting curatorial experiments in contemporary art, are rarely developed within the framework of the museum. My guess is that's because the museum needs to focus on its most treasured holdings — its collection — and is thus hesitant to invest in what is perhaps regarded as overly audacious curatorial practices.

On the other hand, museums also need to develop continuous, long-term programs. Projects are the result of months or years of preparation, which culminate in a short-term event or several interrelated events. What remains a mystery is why these more experimental and dynamic projects are rarely developed in the United States, despite the country's enormous resources and number of institutions, artists, and curators. I can think of only one exception I would include in these project-type exhibitions that happens, at least partially, in the U.S.: InSite, the triennale exhibition that takes place in San Diego and Tijuana, at the Mexican-American border. However, that's a binational project, organized by curators and intellectuals coming from all of the Americas.

What's also relevant is that these projects are developed by somewhat temporary organizations and institutes. Perhaps that says something about the incapacity of the traditional museum to restructure and respond to new forms of curatorial practices and to a different, more profound engagement with art, artists, and the public. For this reason, I believe that the proliferating model of the biennial exhibition, with all its problems, could take on this role in a productive way. But probably because of time and budget constraints, and certainly

because of a lack of political or institutional desire, the large majority of biennales still buy into the model of the one-man show, the exhibition curated by a single person.

CT: How did you develop your interest in curating?

AP: My interest in curatorial practice is related to my engagement with conceptual art and comes from an artist's point of view. At CalArts, I became interested in the framing devices of art: the economy of display and all the elements that come into play such as the gallery, the institution, and the publication. I was making art by appropriating art criticism, using captions from art books, exhibition brochures, frames. The turning point for me was an exhibition I never really saw, Joseph Kosuth's *The Play of the Unmentionable* (Brooklyn Museum, 1990), which has become a key reference for me. It has always been important to develop my work as a curator and as a writer in parallel to my art making, and my projects have often focused on the overlaps between these seemingly distinct activities. Eventually, to avoid ethical problems, I decided to privilege curating and writing over art making, which is now a kind of closeted activity for me. However, as a practising artist, I feel I can establish a different relationship with artists and exhibitions, as well as with art writing. From a theoretical point of view, I have always avoided the term *art critic*, privileging Roland Barthes's notion of the *creative writer*, which is also associated with writing that is not strictly fictional. Although I am interested in contemporary art exhibitions that allow artists to develop new projects, I am also interested in constructing exhibitions by selecting existing artworks from different periods or territories, proposing new juxtapositions and contextualizations — an *exhibition d'auteur*, if you wish — more suited for museums. Of course, I am very influenced by Kosuth, but my practice is also something I learned with Paulo Herkenhoff and was recently able to develop with Ivo Mesquita in *F[r]icciones.*[2]

CT: My only experience of *F[r]icciones* has been through its publication, which diverts from the typical exhibition-catalogue format, with its documentary installation shots and accompanying essay, to be almost entirely visual. I'm not able to read the Portuguese and Spanish texts in the catalogue, so I was left trying to decipher what stories, fiction or otherwise, were being told by the catalogue images. It seems that you and Ivo were consciously bringing together, or perhaps stitching and unstitching ideas, stories, and histories in ways that may offer new

possibilities and connections. And like Kosuth, you ask the viewer to consider how art and ideas are presented and received; however, your project seems much more investigative and less demonstrative. Can you discuss your curatorial approach to F[r]icciones?

AP: I find Barthes's notion of the text extremely useful to think about "reading and writing" exhibitions (among other things). His notion of the text as a passage, an overcrossing, is associated with what he calls *stereographic plurality*, where signifiers are woven, and if they are not individually original (as nothing ever is), their juxtaposition may be. There are multiple layers and entries into the text, and I have tried to find another image when thinking about exhibitions: the hypertext, where dialog boxes are connected in multiple ways, erasing page numbers and blurring the chronology of beginning, middle, and end. This approach was very much present in the design of F[r]icciones, through which we tried to propose several possible entries, in physical and conceptual ways. To give you a concrete example: two of the entries to the exhibition were very much alike, wide corridors that we chose to cover with floor-to-ceiling mirrors. After talking to Gabriel Orozco, we placed two copies of his photograph, *Ball on Water* (1994) on equivalent positions on the two spaces. In one corridor, we placed an allegory of America, a magnificent seventeenth-century sculpture in silver by Lorenzo Vaccaro (*America*, 1692), and a small drawing by the late Brazilian artist Leonilson entitled *Truth, Fiction (Favorite Game)* [Attrib.] (1990), which bears a simple drawing of a man and the words "truth" and "fiction." In the other corridor, we placed an artist's book by Brazilian Waltercio Caldas whose pages are filled with stickers that read "FIM" [end]. We dispersed several fragments of texts from different origins and periods, including many by Jorge Luis Borges, throughout the exhibition. In the catalogue, the Orozco image was juxtaposed with a passage from Borges' *El Aleph,* which was something we had also done in the *Roteiros...* catalogue of the XXIV Bienal de São Paulo.[3]

These corridors were the passages in F[r]icciones where the authorial or *auteur*'s gesture of the curators were most strongly felt. The blending and juxtaposition of historical and fictional texts were equally important; copies of the fragments we had selected were made available to the public as exhibition brochures, and were also printed in the book. All this relates to another notion that I have used in the past: the

Portuguese *histórias*, and which I have translated and bracketed as "[Unlike the more limited English histories, the Portuguese *histórias*, much like the French *histoires* and the Spanish *historias*, may identify both fictional and non-fictional texts, thus marking at once the historical, the anecdotal, and the literary]." The weaving, more than the stitching, is a key activity in this kind of exhibition making, and so is the blurring of the critical, the curatorial, and the creative.

CT: But what do you make of the fact that the curator-as-exhibition auteur has come under a good deal of criticism?

AP: There has been some criticism, particularly of how these kinds of exhibitions may centre themselves in the subject or persona of the curator to the detriment of the artworks or the artists. It has also been said that the exhibitions may manipulate the artworks, submitting them to the curator's theories, views, arguments, thesis, themes, and concepts in an authoritarian or illustrative way. That is, of course problematic, and must be taken into account. However, I don't only see it that way, and I would like to try to put this notion of the exhibition *auteur* (though I'm not too comfortable with the French expression, which comes from film) into a wider perspective.

At least since the sixties we have been witnessing, in several fields and disciplines, a certain skepticism toward purely objective (as opposed to subjective) approaches in the humanities and elsewhere. In literary criticism, there is Barthes, whom I've already mentioned, and his critique of criticism and truth. In history, you have the École des Annales and microhistory, which reflect a critique of the total, unbiased, and detached writing of history, which is also associated with the critique of the master narrative. In ethnography, the presence of the ethnographer in his or her territory of research is far from invisible and, in fact, disrupts the daily life of peoples and cultures, jeopardizing the ethnographer's supposedly scientific and unbiased report. Even in contemporary design and typography, there cannot be truly transparent design; Beatrice Ward's famous image of the "crystal goblet," with typography and design understood as "crystal clear glass," is now seen as utopian, if not naive.[4] We could go on in the same way, with language, with architecture, with art history, certainly with journalism, with the questioning of photography as a reliable truth-revealing machine, and the documentary film genre. Psychoanalysis plays a crucial role in these approaches, with Freud calling attention to the

significance of the most seemingly banal slips of language, which in the end reflect the speaker's subjectivity.

In museum studies this comes up as the critique of the neutrality of the white cube. Behind all this is the notion that the subject of the writer, critic, historian, architect, designer, journalist, ethnographer, and so forth is always revealed through his or her practice; that these activities are always somehow and unavoidably contaminated. It's as if we have been realizing that many layers (some of them yet to be discovered, others doomed to remain undiscovered) exist between us and the world, and we cannot escape or bypass them. The key issue here is representation, and how it is necessarily laden with changing politics and subjectivity. This goes back to my use of *História*, which blends history and fiction, blurring the clear boundaries between these genres, and to my use of textuality and Barthes. To go back to curatorial practice, I see the so-called *auteur* curator as a reflection of these changes (call them postmodern if you wish): someone who acknowledges the impossibility of detaching from his or her cultural and personal context, and who does not struggle to do so, but rather takes advantage of that. In the end, an exhibition is always determined or limited by life experience, perspectives, knowledge, libraries, museums, collections, readings, languages, journeys, conversations, and more.

CT: You've worked at the Bienal de São Paulo, developing a different kind of curatorial practice there. In the last few years, the number of biennial exhibitions all over the world has increased dramatically and has been much criticized. Could you speak about your thoughts on biennales?

AP: They have in fact become the pervasive model and have proliferated very rapidly, often with corrupted concerns or approaches. First, if biennales are suddenly in vogue, this reflects a wider interest in contemporary art, which we need to welcome and try to profit from. Of course, we know how city marketing, for example, plays a role in many of these projects. Yet as curators and art professionals, we should take advantage of the opportunities and resources that become available, and transform them in a productive, challenging, and experimental way, opening up spaces for artists and the public.

Second, we need to accept that the notion of the biennale has definitely entered the art vocabulary, like the museum, the gallery, and the *kunsthalle*. We must understand that the term *biennale* encompasses a wide range of projects. We cannot consider Kassel, São Paulo,

Johannesburg, Valencia, Istanbul, Porto Alegre, Venice, InSite San Diego/Tijuna, the Whitney, and Manifesta in the same way. Even if we look at Nelson Aguilar's Bienal de São Paulo in 1996, Paulo Herkenhoff's in 1998, and Alfons Hug's in 2002, we are speaking of very different projects indeed. In lumping together many projects under the same rubric, and in being dismissive about them, we risk overlooking productive differences and complexities. There is an English expression for that. Throwing the baby away with the water — or something?

CT: Yes, we say, "It's like throwing out the baby with the bath water." It's a strange saying.

AP: Very graphic. We have nothing similar in Portuguese. I was recently in Helsinki in a seminar where the term *festival art* — identifying art made for biennales in an obviously pejorative way — came up.[5] Picture this: many exhibitions make an effort to bring artists to the site to get to know the context or space; the institution then struggles to find funding for these often-expensive new works; and then someone comes along and dismisses it as festival art. Curators similarly make an effort to travel to exhibitions beyond their base, and to see what is going on beyond their borders. Then people call them art jet-setters.

Biennale exhibitions are a potentially interesting model, particularly for those cities that lack an active contemporary art institutional scene. For this reason, I find the Whitney Biennial an utterly superfluous and incomprehensible project, a domestic show hosted in one of the world's most international cities and most dynamic art centres. Exhibitions need to be site specific, responding to the needs, resources, and expectations of the locale. In this sense, biennales need to develop a close relationship with their host city, and they should take on a more experimental role in exhibition making. Museums and more permanent institutions seem to have a harder time fulfilling this role. In places like Istanbul, Sydney, or São Paulo, the biennials also play a crucial educational role for the public and younger artists. For example, the richness of contemporary Brazilian art production, from Lygia Clark and Helio Oiticica onward, is in part a result of fifty years of contemporary art exhibitions brought here by the Bienal.

CT: How is your work as a curator in Brazil different from the work done by curators elsewhere? What specific challenges or issues do you face?

AP: I feel a strong sense of urgency here in Brazil. We have a dynamic community of artists, with many developing original work and enjoying

a wide access to the international circuit. But the institutional scenario is precarious, not so much in terms of spaces and funds for contemporary art, but more so in terms of concepts and exhibition programs. Brazil has generous tax breaks for cultural sponsorship, but since it is all mostly regulated by the market, very sharp contrasts and distortions are generated.

CT: In what sense?

AP: Let's just say that the sponsorships, which are granted through the Ministry of Culture, are not reasonably distributed among projects and institutions. The criteria focus on fundraising or lobbying abilities rather than the relevance of the project. This problem relates to poor curatorial possibilities and opportunities in Brazil. The community of Brazilian artists is undeniably much more dynamic than our curatorial community, and probably much more informed about the curatorial practice, too. It is financially and personally costly to form — to educate — a curator, let alone one who is located in the margins.

CT: What do you mean?

AP: It costs a lot of money to have access to the information, to travel, to see exhibitions in different cities, and there are not many fellowships and grants in a country like Brazil. Contemporary curating demands a huge personal commitment, and I suspect that contemporary art curators who are single have a better chance than married ones. I have this kind of life because I do not have a family. In Brazil, although there is access to contemporary art, more contemporary and challenging curatorial practices are practically nonexistent. With local institutions developing precarious or provincial programs — most of them determined by projects offered with guaranteed funding or sponsorship — the standards remain low. Some recent changes have been made due to the work of curators such as Herkenhoff and Mesquita, both of whom have also had the opportunity to work abroad. In response to this context, we have recently started a program at the Museu de Arte Moderna in São Paulo which invites international curators to speak about their practice to the local audience, particularly to the younger or aspiring curators.

I have made a choice to continue to be based in Brazil, where I feel my work may have a stronger impact. It's been tough, but I have not yet given up. This decision is reflected in my curatorial agenda in several ways. For example, when I meet with younger artists in São

Paulo, Belo Horizonte, or Caracas, I feel I can somehow contribute if I attempt to establish a more active dialogue with them. There is an urgent need for personal engagement in the Latin American context, and it is strongly felt in a place like Buenos Aires, where there are no art schools. I've been speaking to a young critic there, Santiago Navarro, about the importance of the curator or the critic in a situation like that. I was in Buenos Aires a couple of months ago with Sandra Antelo Suarez, the editorial director of *TRANS>arts.cultures.media* with whom I work, and we met a young painter, Manuel Esnoz. Recently, he came to São Paulo for an exhibition, and he told me how the conversation we had in his studio had been important for his work. That's why I believe in the potential for critical performance at the microlevel, the personal level. More and more, it is extremely important to open up possibilities to a younger generation of curators and critics that may allow them to develop their work with different standards and agendas from those of the older generation in Brazil.

CT: How do these conditions play out in your work at the Museu de Arte da Pampulha, in Belo Horizonte?

AP: Museu de Arte da Pampulha is a small museum, the only one devoted to art in Brazil's third largest city. The museum, which is run by the city's prefecture, never had a curator — a situation not uncommon in Brazil — and the director, Priscila Freire, wanted to change this situation and invited me to work there. Now we have three curators there, Rodrigo Moura, the assistant curator, Elisa Campos, the education curator, and myself. Although Belo Horizonte is the hometown of artists such as Lygia Clark, Rivane Neuschwander, Rosângela Rennó, and Valeska Soares, the local community has felt neglected by the art institutions there. I was drawn to this challenge. (I was also seduced by the beautiful mid-century Oscar Niemeyer building, originally designed to be a casino, in which the museum is housed.)

In Belo Horizonte, our focus has been on establishing a close relationship with the artists, opening the museum to create a dialogue with them, and to support their work. We are constantly thinking about possibilities to stretch the museum's small budget to construct continuous, long-term programs, and to translate political demands into productive projects. Rodrigo, the assistant curator, is a young critic who had no experience in curating, so his work there becomes some kind of practical curatorial training too.

We try to treat artists with respect, which is not easy, and which unfortunately is very rare. What I'm going to say may be shocking to you, but I believe that, in general, art institutions in Brazil do not respect the artist, and some colleagues of mine in the northern hemisphere have told me the situation is not so different there. Of course nobody disrespects Gerhard Richter, but ask the younger artists around how they have been treated. Jens Hoffmann wrote to me recently from Berlin saying that he often learns about things from younger artists that make him feel bad about being a curator. This is very serious indeed.

CT: And how does your agenda reflect on your work as editor of *TRANS>arts.cultures.media*, as a writer for magazines, or even as the curator for private collections?

AP: I have chosen to remain independent to continue to make myself useful in different levels and places. *TRANS>* is a multi-lingual periodical and plays a unique role in the panorama of art publications. It provides visibility to artists and writers in a very innovative way; we host projects that no other magazine would publish. With editorial offices in New York and in São Paulo, we are able to develop what we call a bi-hemispheric approach. However, *TRANS>* does face its own harsh financial difficulties. At the Coleção de Paisagens [Landscape Collection] in Rio de Janeiro, of which I am curator, we've been putting together a very focused thematic collection, almost like an exhibition, of contemporary art. We are the only private collection in the country buying emerging international art and doing commissions with young artists. We plan to construct a pavilion and to open the collection to the public, with a special emphasis on educational programming, something which becomes significant in the context of a country with only a couple of international contemporary art collections and none open to the public.

Recently, I was approached by another young Brazilian collector to help him form an art collection, and I said that I'd be interested only if I could also develop a public or institutional program. He became excited with this possibility, and now we are thinking of setting up a small program of grants for younger artists in Brazil. These different activities would be considered conflicting in a place like the United States, yet my position is to take advantage of the resources and opportunities that are available. This is particularly important in a context such as the Brazilian or Latin American one, where private and personal

endeavours play a crucial role in the art circuit, precisely because of the fragility of the institutional scene.

CT: What recommendations would you give to a young or aspiring curator?

AP: I like to think of *myself* as an aspiring curator. But here are some suggestions rather than recommendations. First, study a culture other than your own. Spend some time in a hemisphere other than your own. And make sure you learn the native language. Second, study a couple of other disciplines deeply, beyond art and curatorial studies. Curating is a very privileged profession. In which other profession do you travel to a city you have never been to, and then can immediately be in contact with the most interesting people there, with the young artists? Of course, there are the mafioso types, as in other fields, and there is too much vanity in the business. However, those who have succeeded in the art world are mostly those who have made important contributions. (I can't speak for the market side of the art world.) In the art world itself, I feel people are genuinely working for what they really believe in, perhaps more than in any other field. When I tell people I never take vacations, they don't really understand, but I get restless when I'm in a place where I can't see or talk about art. It can be so difficult for us to clearly separate work and life. Right now, it's Friday late at night, and it's a national holiday here in Brazil, and I'm sitting working at the computer. My last suggestion to a young curator? Learn to be critical, but also generous.

1 Ivo Mesquita worked with a team of curators in the construction of the XXV Bienal de São Paulo from July 1999 to July 2000, when he resigned. Adriano Pedrosa helped conceptualize the project at the Bienal de São Paulo, under Ivo Mesquita's direction, with Barbara Vanderlinden, Louise Neri, Lilian Tone, and Cuauhtémoc Medina.

2 The single wall text in the exhibition, reproduced in the publication's gatefolds in Portuguese and in Spanish, read:

> *F[r]icciones* articulates the notion of Jorge Luis Borges's fiction with that of friction, with the intention of constructing a complex and incomplete panorama of Latin American art. In his book *Ficciones* (1935-44), Borges questioned the clear distinctions between literary and textual genres, compiling texts that individually blur these boundaries, bringing together fiction, criticism and history. *F[r]icciones*, the book and the exhibition which accompanies it, attempts to call attention to frictions which exist between history and fiction, between art and text, between historical and contemporary works, but also between their multiple media, languages, formats, designs and contents. Some thematic and formal leitmotifs (always in friction) are articulated in this narrative: the grid and the web, the cities and the maps, the fragments and the texts, the ethnic and cultural composition. *F[r]icciones* presents itself as an allegory, a procession of images and texts, weaving a web, a net, a labyrinth where also inhabits some of the landscape, peoples and histories of Latin America.

In Ivo Mesquita and Adriano Pedrosa, *F[r]icciones* (Madrid: Museo Nacional Centro de Arte Reina Sofía, 2001).

3 Adriano Pedrosa, ed., *"Roteiros. Roteiros. Roteiros. Roteiros. Roteiros. Roteiros. Roteiros."* (São Paulo: Fundação Bienal de São Paulo, 1998), 330-31.

4 Beatrice Warde, *The crystal goblet*, 1932, as quoted in J. Abbott Miller and Ellen Lupton, "A natural history of typography," in Michael Bierut et al. ed., *Looking closer: critical writings on graphic design* (New York: Allworth Press, 1994), 25.

5 Unfolding Perspectives: Three days of lectures and discussions at the ARS01 exhibition, Kiasma — Museum of Contemporary Art, NIFCA — Nordic Institute for Contemporary Art, Helsinki, 2002.

LEE-ANN MARTIN is an independent curator living in Ottawa. Martin was head curator at the MacKenzie Art Gallery, Regina, Saskatchewan (1998–00), where she continues as adjunct curator, First Nations Art. Martin is curatorial fellow (2001–03) with the Walter Phillips Gallery, Banff, Alberta. She held the positions of First Peoples equity coordinator at the Canada Council for the Arts (1994–98), and interim curator of Contemporary Indian Art at the Canadian Museum of Civilization, Hull, Quebec (1992–94). In 1992, Martin cocurated, with Gerald McMaster, the internationally travelling exhibition, *INDIGENA: Perspectives of Indigenous Peoples on 500 Years*. She has curated numerous exhibitions and published essays on critical issues in contemporary First Nations art in Canada. She holds a master's degree in museum studies from the University of Toronto.

■

An/Other One
Aboriginal Art, Curators, and Art Museums

LEE-ANN MARTIN

ABORIGINAL ART IS AT AN IMPORTANT, and perhaps ironic, juncture relative to Canadian art institutions. An ongoing critical discourse challenges the dominant role that art museums play within the arts environment, providing a privileged framework for selected art histories and contemporary art practices. Many "mainstream" art curators reject the museum in their pursuit of independent professional practices. At the same time, Aboriginal art curators criticize their continued exclusion from staff at these institutions as well as the token inclusion of Aboriginal art in collections and exhibitions. This systemic omission of Aboriginal art and Aboriginal museum professionals from a national arts infrastructure remains an unresolved issue not only in Canada but also in many countries throughout the world. The strategic inclusion of Aboriginal curators will unquestionably strengthen institutional commitment to Aboriginal art. More importantly, an expanded curatorial infrastructure allows for a critical exploration of overlooked and under-represented aspects of Aboriginal art history as well as contemporary art practices. The need for curators from Aboriginal communities in the development of collections, exhibitions, and programs at mainstream art museums is long overdue. In an effort to address these issues here, I discuss two recent curatorial projects that illustrate aspects of my professional practice: the development of an inclusive Aboriginal art history and curatorial collaboration.

According to Pueblo/Mexican American art historian and curator Margaret Archuleta, "The paradigm of exclusion follows the belief that if an art form is perceived to have no history or an invalid history, then it cannot be recognized as a valid area of study and therefore cannot be included in mainstream art history."[1] She concludes with the bleak prediction of continuing exclusion unless Native artists and Native museum professionals assume positions of self-determination in relation to these institutions.

The inclusion of Aboriginal art histories in mainstream art galleries requires more consideration than a simplistic redefinition of Aboriginal historical work from artifact to art. The process leading to long-term inclusion faces a multitude of challenges within a mainstream context, only a few of which are identified here. Most collections of Aboriginal historical objects are located in private collections, in anthropology and history museums, and in Aboriginal communities, not in the collections of art museums. Because the works of many Aboriginal contemporary artists are increasingly influenced by their histories and traditions, an expert knowledge of the culture is often required. Infrequent and sporadic exhibitions of historical Aboriginal art greatly limit a better understanding of the continuous art traditions of Aboriginal communities. Only sustained commitment to this history can provide greater insights. Currently, most curators within public art institutions in Canada and elsewhere are outside the "other" cultural community to be presented in an exhibition. As recently as 2000, an editorial in *Inuit Art Quarterly* asked: "What, then, is the role of the curator if *other* points of view are to be incorporated into exhibition planning and interpretation?"[2] Complex histories, traditional knowledge, and contemporary issues necessitate the dynamic involvement of professional curators from Aboriginal communities in positions of authority to lead this process of inclusion.

Why has Aboriginal art received at best only sporadic attention, and at worst been excluded from most mainstream art galleries? A study completed in 1990 for the Canada Council for the Arts addressed the inclusion and exclusion of contemporary First Nations art in public art galleries in Canada.[3] At that time, few institutions demonstrated even a minimum level of commitment to the collection, exhibition, and documentation of Aboriginal art. However, within a few years following this study, the armed standoff at Oka, the Meech Lake Accord, and the five-hundredth anniversary of European arrival in the Americas heightened national consciousness around Aboriginal issues in Canada. At the same time, increasing pressure from First Nations artists contributed to the brief flurry of exhibitions and publications in many institutions throughout the 1990s. In 1996, the Canada Council for the Arts introduced the Acquisitions Assistance

Program to provide much-needed funding for collections development in public art museums. Until 1999, the program included an incentive for the purchase of contemporary Aboriginal art that substantially increased the representation of Aboriginal art in numerous permanent collections.

Despite such heightened activities of the 1990s, the important role that Aboriginal curators play in shaping an inclusive framework for Aboriginal art has been addressed only recently. In February 1997, the First Peoples Secretariat at the Canada Council for the Arts invited seventeen Aboriginal art curators to Ottawa to discuss issues and future strategies related to their practices in visual arts.[4] This was the first national meeting of Aboriginal art curators, and it focused largely on the curator's role in developing exhibitions. Discussions ensued surrounding questions of individual curatorial relationships with art institutions and their responsibilities to Aboriginal communities. Aboriginal curators practice with the privilege of their community and frequently must negotiate between the value systems of Aboriginal communities and those of non-Aboriginal "mainstream" institutions, at the regional, national, and international levels. Participants noted that they rarely have opportunities to work with institutions on a regular, long-term basis to develop a strong, supportive infrastructure for Aboriginal art. Aboriginal art curators work on a project-to-project basis, usually at the invitation of the host institution, and they very rarely are included on the permanent staff of public art museums in Canada. This gap continues to be a key factor in the continuing absence of Aboriginal art from the framework of Canadian art.

In direct response to the recommendations made at this historic meeting, the First Peoples Secretariat and the Visual Arts Section at the Canada Council for the Arts developed the Program of Assistance to Aboriginal Curators for Residencies in Visual Arts. The program provides support to curators-in-residence to develop exhibitions and publications on various aspects of contemporary Aboriginal art. From 1998 to 2001, these projects represented a large percentage of the activities related to Aboriginal art across the country. Few have strengthened and expanded their commitment to Aboriginal art beyond the availability of this targeted funding program. Few public art museums have continued their support of Aboriginal curatorial practices beyond the scope of the residency, through the hiring of the curator-in-residence or another Aboriginal curator, either as permanent staff or as guest or adjunct curator. A strong curatorial infrastructure throughout Canada's public art galleries will ensure a lasting commitment to Aboriginal art.

Although an individual curator's activities necessarily change and shift with each endeavour, aspects of my recent projects share similar concerns with many

Aboriginal curators in Canada. My practice is based on a passionate commitment not only to Aboriginal contemporary art practices but also to under-recognized art histories. As well, I am a strong champion of the need for the sustained involvement of Aboriginal art curators within public art galleries. In 1998, when I was appointed head curator at the MacKenzie Art Gallery in Regina, Saskatchewan, I seized the opportunity to address the linked issues of inclusion and representation.[5] Since 1982, the MacKenzie Art Gallery had organized numerous exhibitions and publications related to Aboriginal art. With a growing population of Aboriginal peoples in the province, and the proximity of Saskatchewan Indian Federated College and other Aboriginal arts and culture organizations, Regina is an important site from which to develop strategies of inclusion for First Nations art.

As the largest public art gallery in Saskatchewan, the MacKenzie Art Gallery has an important responsibility to engage its wide audiences in a better understanding of Aboriginal art and artists. To this end, works by Aboriginal artists are regularly included in all exhibitions developed from the MacKenzie's permanent collection. A strong program of acquisitions further strengthens the integration of Aboriginal art within these exhibitions. Aboriginal artists are included routinely in solo exhibitions for the Studio Series Program as well as MacKenzie Outreach — Provincial Extension Program, both of which profile Saskatchewan and regional artists. Yet, as the contemporary works of many Aboriginal artists became regularly presented to many diverse audiences, I became preoccupied with the continuing omission of historical Aboriginal art within the gallery context. This history remains largely untold in the canon of Canadian art history.

Two major exhibitions were based on my desire to develop inclusive art historical frameworks for underrecognized works, artists, and issues. These projects also allowed me to work closely with respected colleagues in dynamic co-curatorships. In the recent past, there have been various models of collaboration with artists and with underrepresented ("other") communities by non-Aboriginal staff at museums. As an Aboriginal curator, I must work collaboratively, where appropriate, with colleagues from the Aboriginal curatorial community. Aboriginal curators come from diverse First Nations cultures, with a complex spectrum of individual and community histories, perspectives, and art practices. Curatorial collaborations strengthen personal and professional alliances around common concerns and, at the same time, enhance the knowledge and expertise required for the project. Such *co-curatorships* generate increased dialogue not only among the curators, artists, communities, and audiences, but also with staff at the institutions. As the only Aboriginal person on staff at the

MacKenzie Art Gallery, I believed it was vitally important to include at least "an/other one" from the Aboriginal community working within the institution.[6]

The exhibition, *EXPOSED: Aesthetics of Aboriginal Erotic Art* (September 24 to December 5, 1999) brought together for the first time images that celebrate and reclaim aspects of sexuality, eroticism, desire, and longing within an Aboriginal cultural context. Morgan Wood and I developed our curatorial premise as a result of a series of discussions with various artists, curators, and friends about the need for dialogue on sexuality, intimacy, and the richness of human relations in the Aboriginal community within a contemporary context. These discussions began while we both lived in Ottawa, where Morgan was a curatorial assistant for Canadian art at the National Gallery of Canada, and I was preparing my move to the MacKenzie Art Gallery. These conversations continued with elders and other individuals in Morgan's home territory after my relocation to Saskatchewan.

The central premise of this exhibition was to demonstrate that erotic and sexual stories and images continue to hold significant places in First Nations communities. As Aboriginal curators, we are well aware that erotic imagery has a long history within our communities. However, several generations of First Nations people suffered through the repressive experience of church-run residential schools where they were separated from family and community, and ordered to forget their original languages and spiritual beliefs. For many people, sexual abuse while in the schools further contributed to feelings of shame and confusion. This exhibition was created to render visible a selection of erotic images intended to begin a dialogue within the community.

Daphne Odjig, Big One and the Bad Medicine Woman, *1974, Screenprint, a/p, 119.3 x 79.3 cm. From the collection of the MacKenzie Art Gallery, Regina, Saskatchewan. This image was created for the book of Aboriginal erotic stories,* Tales from the Smokehouse *(1974). The publication had an important impact on recent generations of Aboriginal artists. Photo by Don Hall, AV Services, University of Regina.*

Rather than attempt an exhaustive presentation of this art history, we focused on the recent history of erotic imagery of the past thirty years. The senior generation of artists — Daphne Odjig, Norval Morrisseau, and Robert Markle —

provides inspiration for subsequent generations of image makers represented in this exhibition.

EXPOSED "uses the filter of aboriginal sexual experience and sexual identity to dispute the shallow readings of First Nations culture made by dominant Euro-Canadian society."[7] By exposing this underrecognized art history and reclaiming Aboriginal erotic imagery, we rejected a colonial history that has hidden Aboriginal erotic images and stories for too long.

Rosalie Favell, *Pillow Box 3, 1999, lightbox, 66.0 x 85.0 (image). From the collection of the MacKenzie Art Gallery, Regina, Saskatchewan. Using an icon of popular culture – Xena, the warrior princess – Favell expresses the erotic in the anticipation of touch and intimacy. Photo by Rosalie Favell.*

Opening a year later, *The Powwow: An Art History* (September 22, 2000 to January 28, 2001), *co-curated* with Bob Boyer, presents one hundred years of Aboriginal art history in relation to the development of the powwow throughout North America. For many years before joining the MacKenzie Art Gallery, I observed the increasing prevalence of powwow imagery in contemporary First Nations art. After arriving in Saskatchewan, I found my enthusiasm for organizing this exhibition and publication was fuelled by the fact that Bob Boyer, noted artist, art historian, and powwow dancer, lived and worked close by. Boyer had wanted for some time to organize an exhibition of historic images of the powwow. His knowledge of both the art history and the contemporary experiences of the powwow, and my experience with contemporary First Nations art resulted in a strong *co-curatorship*.

The powwow is one of the most visible, prevalent aspects of contemporary Aboriginal life, developing from a long history of social and ceremonial dancing. Today, the powwow is a symbol of cultural survival and celebration across North America. It is an opportunity not only to sing and dance, but also to visit, watch dances, and enjoy the food and crafts. Powwow images reveal a fluid framework in which the roles of participants and audiences shift and change throughout the event. At times, spectators can participate as dancers, while dancers move between the highly visible, central dance arena and the many circles within the powwow

grounds. This exhibition recognizes over a century of diverse artistic expressions that, despite complex and frequently traumatic changes, still respect and acknowledge strong cultural associations. Many of the artists at the turn of the twentieth century produced powwow images based on personal experiences with traditions during this era of rapid change. Today, artists throughout North America often incorporate powwow imagery as a symbol of cultural survival and celebration.

How do these exhibitions challenge the exclusion of Aboriginal art history from the prevailing canons of Eurocentric art history and theory? Both exhibitions include artists and artworks important to the history of Aboriginal art in North America. Still, such artists and artworks continue to be underrepresented and excluded from an inclusive art history. The impact of these exhibitions may be minimal if ongoing explorations of this history are not supported by art museums

Allen Sapp, The Pow-Wow, 1987, acrylic on canvas, 101.6 x 152.4 cm. From the collection of the MacKenzie Art Gallery, Regina, Saskatchewan, purchased in memory of Mari Stewart. As a powwow dancer himself, Sapp has developed a personal beadwork design that is frequently recreated and repeated in his work, respecting a powwow tradition of not appropriating another person's designs. Photo by Don Hall, AV Services, University of Regina.

in the future. But the arts infrastructure in Canada is a close-knit community in which initiatives by a single institution can be the impetus to change how many art museums function. And major funding agencies, such as the Canada Council for the Arts, can play a role to offer incentives for change and to recognize those institutions that implement long-overdue initiatives.

This preoccupation with the presentation of continuous elements of Aboriginal art history defines my curatorial practice today. Future projects range from a focus on Iroquoian artistic traditions to an expansive exploration of international indigenous concerns. Some projects involve collaborations with Aboriginal curators and cultural workers that strengthen personal friendships and expand professional insights. My practice continues not only to affirm Aboriginal artistic expression but also to challenge its agents of exclusion. Perhaps, in this way, Aboriginal art, curators, and art museums will work within an environment of respect for one an/other.

1 Margaret Archuleta, "Issues of Exclusion: A History of Native American Fine Art Exhibitions within the United States," *Thunder Bay Art Gallery Mandate Study, 1990–93* (Thunder Bay: Thunder Bay Art Gallery, 1994), 21.

2 Marybelle Mitchell, "Balancing Needs," *Inuit Art Quarterly* 15, no. 4 (2000): 3 (emphasis Martin's).

3 Lee-Ann Martin, "The Politics of Inclusion and Exclusion: Contemporary Native Art and Public Art Museums in Canada, A Report Submitted to the Canada Council" (Ottawa: Canada Council, 1991).

4 For a summary of the discussions at this meeting, see Lee-Ann Martin and Morgan Wood, "Shaping the Future of Aboriginal Curatorial Practice," *Inuit Art Quarterly* 13, no. 2 (1998): 22–25.

5 When I was hired in March 1998, three Aboriginal art curators were employed on a permanent basis — all of them at institutions with Aboriginal-specific mandates — Barry Ace, chief curator, Indian Art Centre, Department of Indian and Northern Affairs, Hull, Quebec; Tom Hill, director, Woodland Cultural Centre Museum, Brantford, Ontario; and Gerald McMaster, curator of contemporary Indian art, Canadian Museum of Civilization, Hull, Quebec. Due to family circumstances, I returned to Ottawa in November 2000 but continue as adjunct curator, First Nations Art at the MacKenzie Art Gallery to develop exhibitions on regional, national, and international levels.

6 As First Peoples equity coordinator at the Canada Council for the Arts (1994 to 1998), I had the opportunity to hire Morgan Wood on a short-term contract to assist with the organization of an Aboriginal curatorial meeting, held in February 1997. In response to my request to management for this contract position, I was asked to justify why previously I had "one" (Aboriginal officer, Rocky Paul-Wiseman, hired on contract in 1995-96) and now why I wanted "another one." At that time, I was the only Aboriginal person on permanent staff.

7 Jack Anderson, "Aboriginal Sexuality Revealed in Exhibit," *Regina Leader-Post,* November 12, 1999, sec. D12.

LILIAN TONE is the assistant curator in the Department of Painting and Sculpture, the Museum of Modern Art, New York. She holds a B.A. from the Fine Arts College, Armando Alvares Penteado Foundation, São Paulo, Brazil, as well as a B.A. from the Law School at the University of São Paulo. She is a Ph.D. candidate at the City University of New York. From 1984 to 1998, Tone was the assistant coordinator of the education program at the São Paulo Bienal, and she was the adjunct curator at the São Paulo Bienal (1999–00). Tone acted as research assistant and curatorial assistant at the Museum of Modern Art, New York. She has held curator positions at Actual Size (2000) and White Spectrum (2000), and was curator or co-curator on projects with General Idea; Karin Davie, Udomsak Krisamanis, Bruce Pearson, and Fred Tomaselli; William Kentridge; and John Armleder and Piotr Uklanski, at the Museum of Modern Art, New York. Lilian Tone's published work includes numerous exhibition catalogues, as well as other publications.

□

Affording the Ultimate Creative Shopping Experience
The Boutique of the 1984 Miss General Idea Pavillion

LILIAN TONE

MUSEUMS HAVE TRADITIONALLY YEARNED to arrest the natural course of things: they aspire to conserve the perishable, to retain the ephemeral, to congeal process. By temperament and mission, they refuse to let go, and so restore, climate control, document, explain, and overexplain, at times despite the intrinsic inclination and expressed intention of certain works to disappear into oblivion or dust. At a time when event-driven, performance-related works abound, one question keeps recurring to any contemporary art curator working in an object-oriented institution: how to deal with this kind of practice in the collection, balancing legitimate institutional concerns regarding security and conservation with the artist's intended reception of the work? Are some works just not meant to be collected and preserved? If so, how can they be presented and represented in the collection? To what extent are museums misrepresenting certain works, or turning them into fetishes, by making endless efforts to maintain them in the world? At what point does one decide that enough is enough? No rule can be drawn from the unique and complex relationship that each different work brings to the world, both aesthetically and historically. Moreover, it is the curator's role to problematize the issues involved by keeping the contradictions in place — for it seems to be unavoidable, at times, to be torn between the institution's perspective and that of the artist — and to responsibly consider and sensitively propose alternatives when displaying and acquiring works that rely on interaction with the audience, and thus on actual time.

Drawing on my own still-unresolved questioning, despite a decided commitment to General Idea in general, and to their *Boutique of the 1984 Miss General Idea Pavillion* (1981) in particular, I will discuss some of the issues around the past and future of that work by this groundbreaking, eye-opening Toronto-based artist collective. My point of departure is my personal interest in General Idea's

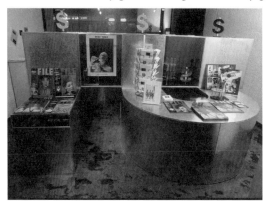

work, which has been greatly nourished and expanded over the last five years by several enlightening conversations with AA Bronson. I was involved with General Idea on two occasions. In December of 1996, I curated a Projects exhibition at the Museum of Modern Art, New York, that included two installations central to the AIDS-related projects developed by the group after 1987, *One Day of AZT*

The Boutique at the Carman Lamanna Gallery, Toronto, Ontario, 1981. Courtesy AA Bronson.

(1991) and *One Year of AZT* (1991), from the collection of the National Gallery in Ottawa. In 1999, I assisted Kynaston McShine, the exhibition's curator, in the preparation of *The Museum as Muse: Artists Reflect*, also held at the Museum of Modern Art, which included the *Boutique*. This essay is an attempt to point to some of the complex issues raised by the display of the *Boutique* today, as it continues to maintain a degree of resistance to being institutionalized. But first I would like to describe some key aspects of the work's background.

General Idea was formed in 1969 by AA Bronson (b. 1946), Felix Partz (1945–94), and Jorge Zontal (1944–94), and was prematurely dissolved after the deaths of two of its members. Partz and Zontal granted Bronson complete power to decide on artistic issues in their name and to realize existing but never-produced projects. During twenty-five years of professional and domestic partnership — one of the longest collaborations in twentieth-century art — General Idea created work marked by elusive meaning and poignant wit that addressed both popular culture and mass media. Between 1971 and 1987, General Idea painstakingly built a complex mythology to internalize, as well as comment on, the art world. The *Boutique* was an essential part of a series of projects conceived for the *1984 Miss General Idea Pavillion*, a decentralized structure consisting of various installations dispersed around the world, collectively forming an

autonomous "museum," functioning within yet unrelated to its host sites. Shaped like a dollar sign, the Boutique looks like a hybrid of minimalist sculpture and sales counter, an apt reflection of its dual function of artwork and shop, and of the ambivalent (and not necessarily harmonious) coexistence of its contemplative and interactive dimensions.

Fabricated by a company that produced ventilation systems, the counter showed its industrial origin: the galvanized metal structure looks remarkably similar to that used for heating systems and industrial ducts. Made at a time when the sound of cashiers still seemed outlandish in the immaculate environment of the exhibition space, the Boutique presaged the increasing pervasiveness of temporary shops occupying space once exclusively assigned

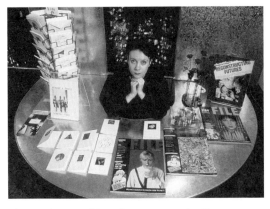

The Boutique *and its saleswoman at the Carman Lamanna Gallery, Toronto, Ontario, 1981. Courtesy AA Bronson.*

to art. The *Boutique* functioned as a museum store inserted into galleries, exploring the increasingly visible connections associated between art, merchandise, and commerce, and offering a selection of General Idea's extensive production of publications and multiples for sale.

In its original set-up at the Carmen Lamanna Gallery in Toronto in 1981, the *Boutique* was placed parallel to the gallery's wall-to-wall front window (a side of it could be seen from the street), making the gallery appear, from the sidewalk, like an ordinary shop.[1] A full-time saleswoman worked behind the *Boutique's* minuscule, cramped counter for the duration of the show, and the public was invited to touch and handle the various items on display. Every aspect of the work contributed to its detachment from the rarefied system of aesthetic concerns and its insertion into real life or, more precisely, the commercial side of real life.

From their beginning, General Idea adopted a strategy of appropriating nonart formats from the mass media and popular culture — beauty pageants, television shows, popular magazines — inserting novel contents into highly familiar forms. The *Boutique* project allowed a foray into previously unexplored domains: the boutique culture and the mail-order catalogue. The contemporaneous issue of *File Megazine*[2] featured a section on the *Boutique*. The accom-

panying text is reproduced here, partly for its sharp and whimsical language, interweaving humour and ambiguity, irreverence and extravagance, so representative of General Idea's editorials in *File*, but especially for the background it provides for the *Boutique*. It underlines General Idea's direct treatment of issues relating to the artwork as commodity, expressed in the headline "General Idea's Cocktail Boutique from The 1984 Miss General Idea Pavillion: Turning Ideas into Cash and Cash into Ideas":[3]

> The vaguest little longing ... just a yen, really ... a sense of anticipation ... a flight of fantasy ... some small inner awakening ... a fluttery hope for your wildest dreams ... That momentary twinge of ... is it guilt? ... that holds its own naughty thrill. And then ... the elation that follows. Something unattainable suddenly attained. Mine! is it really so dreadful to say it? After all, the thought is there and yes it is ... smug ... the sense of possession ... of ownership of something that is absolutely, definitely, finally perfect. Something you searched for and found and acquired. And every time you gaze upon it you feel radiant, exuberant, and content. When you feel those acquisitive urges ... the ones that can only be satiated by a financial transaction ... and the climax of possession ... Why not move up-market to a creative shopping experience? Why not commemorate your possessive urges with souvenirs of your shopping excursions and trophies of your acquisitive safaris? And there is only one place to find them. One place in all the world. And that is the boutique of the 1984 Miss General Idea Pavillion.

> Browse through our catalogue and then shop in person ... or use our convenient phone and mail-order service ... unleash your buying power at the 1984 Miss General Idea Pavilion.

Subsequent pages of this issue of *File*, devoted to "$ucce$$," feature General Idea multiples originally available at the *Boutique*, graphically presented in the magazine as supermarket weekly specials in the form of promotional handouts and coupons. The multiples relate to props from General Idea's "made-for-television videotape" *Test Tube*, and they are flamboyantly described by the artists in the magazine as "Architectonic Doric Column Test Tube Holder," "Greeting

Cards 8 Cheers from the Colour Bar Lounge," "Magic Palette Attractively Packaged with 6 Magnetic Cups on Chrome Server Plus Getting into the Spirits Cocktail Book," "Liquid Assets New Improved Soon to Be Released Frosted Plastic Cold Cash," and "Ziggurat Test Tube Holder 5 Test Tubes Included, Double Palette 5-Tube Test Tube Server Clear with Black Plexiglas Plus Chrome Handle."

With time, the conditions for the presentation of the *Boutique* naturally changed. In subsequent showings, adjustments were made to the overall display, to the multiples and publications available, and to the salesperson's schedule. At 49th Parallel in New York, when it was exhibited later that same year, a salesperson was available all day Saturdays and for a couple of hours during the week. At other times, a sign

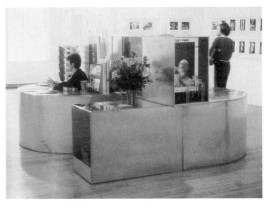

The Boutique *at 49th Parallel, New York, New York, 1981. Courtesy AA Bronson.*

would mark the salesperson's absence. During the General Idea touring show in 1984, the *Boutique* was not included in Basel, only in Eindhoven, Toronto, and Montreal. In Eindhoven, there was no salesperson, but handling was still permitted. Likewise in Toronto, with the difference that the Art Gallery of Ontario's shop carried the multiples and publications for sale. In Montreal, the *Boutique* was installed in an entrance hall adjacent to the museum store, a situation in keeping with the ambiguous function of the piece, allowing it to bypass the museum's sales structure by offering an alternative shopping site.[4] This kind of immediate proximity, without incorporation into the institution's store, was likewise adopted at later venues such as the ICA in London, where the *Boutique* items were handled and sold. At Spiral Gallery in Tokyo, it was presented as part of their large shop, with a member of the staff sitting in the *Boutique*.[5] At the time of these presentations, the *Boutique* belonged to the artists, allowing them to freely add and subtract from the items on display according to the development of their production and in response to each new setting.

At this moment in the *Boutique*'s life (or its afterlife?), not only have the conditions for its presentation changed dramatically, but many aspects concerning its display can no longer be duplicated. General Idea has ceased operations since the deaths of Jorge Zontal and Felix Partz in 1994, so the once-prolific output

of unlimited edition multiples and publications is no longer replaceable at will. Moreover, such items have become rare and expensive. In 1998, Sandra Simpson, General Idea's collector and former dealer, donated the *Boutique*, along with its component display items, to the Art Gallery of Ontario, giving it a home that it shares with several other key works by General Idea, many of which are kept on permanent display.

The Boutique *at the Musée d'art contemporain de Montréal, Quebec, 1984. Courtesy AA Bronson.*

The first attempt to present it in a closed, archival format was on the occasion of the Museum of Modern Art's *The Museum as Muse: Artists Reflect*, which inadvertently turned into a laboratory for the presentation, or rather representation, of the *Boutique*. AA Bronson had to face restrictions that had never been posed, with the pains and difficulties of decision making compounded by the absence of his partners. For security and conservation reasons, the public was not allowed to handle the *Boutique*'s items. Its interpersonal and commercial dimensions had to be conveyed by a long explanatory label and photographic documentation showing a salesperson in action during the first installation at the Carmen Lamanna Gallery. Despite these attempts to draw attention to the piece's impropriety of function and location, the *Boutique* looked oddly polite in its silent self-centredness, its passive objectification standing in contrast to its former active incarnation. Perhaps unavoidably, a significant portion of the experience of the piece was lost in this documental format. The informal perusal of the objects, their potential acquisition, the exchange of money — all that remained from these experiences was their representation. The piece had turned into its memory, a residue, an index of a series of past activities, not much different from photographic and video documentation of performance art. Likewise, the work's status as a social fact — its foregrounding of the audience and its reliance on real time and space — was only suggested. Would the social aspect of the work have been preserved if a salesperson had sat idly behind the counter? Perhaps this aspect might have been implied, but only at the risk of offering an empty re-enactment, or displaying a meaningless parody, for lack of anything available for sale.[6] What had been lost from the experience of the *Boutique* was the fanning of desire, the desire articulated in the above General Idea quotation,

written in insinuating, sexy prose, advertising the *Boutique*, and the fantasies of possession and self-fulfillment it entails.

Similar challenges were posed at least thirty years ago, when ephemeral, dematerialized art became a particularly favoured form of expression. These strategies, hand-in-hand with land art practices and performance art, not only critiqued the art object as commodity but essentially embodied an antimuseum attitude, literally equating institutionalization to death. The disappearance, or "uncollectability," of a work was a given or it was negligible, or, in many cases, an inseparable part of its meaning.[7] In recent years, despite the profusion of work that explores unconventional, open-ended modes for addressing the audience, the issues at stake seem to be of a

The Boutique *at the ICA, London, England, 1984. Courtesy AA Bronson.*

different nature, notwithstanding their undeniable debt to the 1960s and 1970s. Felix Gonzalez-Torres and Rirkrit Tiravanija, for example, accounted for the institutional afterlife of a number of their works, and the instructions for that afterlife have become an intrinsic part of the work's meaning. The *Boutique* seems caught between two generations and attitudes: those who rejected the objectness of the work entirely and, most recently, those who found ways to incorporate provisions for the work's disappearance and reappearance.

Much of the *Boutique*'s power resides in its ambiguous perception by the public, in the uncertainty of looking at a shop or at an artwork. Of course, a balance is required for that ambiguity to be maintained, and perhaps that is where the main difficulty lies. Along parallel lines, one might ask if the *Boutique* is merely the stage setting for a series of actions, like some of the numerous multiples that it originally offered for sale. (Many of them appeared as props in the video *Test Tube* before turning into artworks in their own right.) Or one may see the *Boutique* as a multipart sculpture that once had an interactive component. Recently, AA Bronson considered accepting and incorporating these limitations by installing the *Boutique* on a low base, at arm's length from the visitor, clearly signalling its current institutional status. But this solution was abandoned, because the artist was understandably reluctant to diminish, beyond what time had already accomplished, the suggestion that an exchange had once taken place.

Reflection on these circumstances coloured my thinking about how a work presents itself to the audience, and the range of feelings, from generosity to antagonism, that such presentation entails. Recently, some contemporary artists have indicated a desire to renegotiate their relationship with the public, using diverse strategies to promote an inviting, and sometimes perplexing experience. Working in contrast to the avant-garde tradition of outraging and scandalizing the public — and unlike the didactic approach of much conceptually-based work or, more recently, ideologically inflected works focusing on cultural and gender politics — these artists actively engage the viewer in a hospitable, accommodating way. Some of the situations involved promote interpersonal connections and transport intimate relations into the social realm, spanning the space between personal life and public exhibition. In a tongue-in-cheek dialogue with the traditions of institutional critique and site specificity, they promote what could be called a situational displacement, heightening awareness of the shifting frame that defines the spaces where art is shown: spaces marked by unstated formal and ethical codes, in which accepted rules of engagement forbid ordinary reflexes of attraction: touching, taking away, tasting, sleeping with ... The *Boutique* operates in similar terms, simultaneously generating comfort and discomfort, freedom and self-consciousness, and posing, to the institution, a challenge to its powers of adaptability.

1 To allow the gallery's door to open in this first showing, the *Boutique* had to be installed backwards; that is, the "$" appears inverted.

2 In April 1972, General Idea began issuing a periodical, *File Megazine*. It became General Idea's main outlet for their interest in language, as well as a powerful means of networking for artists.

3 *File Megazine*, 5, no. 1 (March 1981): 24-25. According to AA Bronson, the text quoted here was inspired by (and whole portions of it were lifted from) an ad published in the *New York Times*, possibly for a department store such as Lord & Taylor or Bergdorf Goodman.

4 According to AA Bronson, the multiples were for sale in this venue, though there was no staff in the *Boutique*.

5 AA Bronson recollects that the Japanese were very much at home with the commercial dimension of the piece and were enthusiastic about carrying out its intent.

6 Other attempts were made to breathe life into the *Boutique*, such as adding a vase of fresh flowers on the desk and extra spotlights. AA Bronson also had the idea of producing a postcard, to be given away to the public, as a way of re-establishing an interactive component.

7 Two famous predecessors of the *Boutique*, Claes Oldenburg's *Store* and Al Ruppersberg's *Al's Café*, no longer exist except in documentation and relics. Notwithstanding these important antecedents, the *Boutique* probably found its origins in three moments of General Idea's own multi-entrepreneurial history and prehistory: Jorge Zontal's *The Belly Store* of 1969, a Toronto storefront that was General Idea's first headquarters; and, of course, Art Metropole, the archive and artists's space the trio founded in 1974 (and still continue to operate), which established a homegrown system of communication and distribution.

PIP DAY is an independent curator based in New York and Mexico City. Her past curatorial projects include: *Residue* (Kunsthalle Exnergasse, Vienna, 2000); *Faucet* (Exit Art, New York, 1999); *Performing Video* (Ex-Teresa, Mexico, D.F., 1999); *Horizons of Language* (Center for Photography, Woodstock, N.Y., 1999); *Shifting Spaces, Reading the Shadows; Stan Douglas and Nicholas Africano* (Center for Curatorial Studies Museum, New York, 1997); and numerous exhibitions while curator at Artists Space (New York, 1996–98). Day received her M.A. at the Center for Curatorial Studies, Bard College, 1995, where she taught from September to December 2001. She is contributing editor for *Cabinet*, and founding member of teratoma, a Mexico City based arts organization for which Day is running RIM, an international residency program, and a course in curatorial studies.

Faucet

PIP DAY

□ □ □ □ □

1/16/99

Faucet,
in Paradise 8,
Exit Art/The First World, 548 Broadway, New York, N.Y.
January 16 to April 1999

Start with the binder marked Submissions.

Each submission to Faucet has been registered and categorized. In the box on the *upper-left corner* of each registration form, you will find a call number (a letter followed by a three-digit number).

→ The numbers simply indicate the order in which the submissions are received.

→ The letters indicate where you will find the submission within the archive:

Legend

A = binder on desk shelf (contains submissions on paper)
AW = artist's work (location in gallery also indicated)
B, C, D, E = box files on desk shelf (contain catalogues, books, and other printed matter)
F = filing cabinet (contains videos)
S = lower-right drawer of desk (contains hanging files of slides)

▢ ▢ ▢ ▢ ▢

His hand turned the tap and activated
an entire system of circulation; public and
private met, interior and exterior fused.

Pretext

Exit Art has offered its space to eight independent curators for a three-month period. There is a decent budget, no restrictions. The group of curators is to meet regularly over the course of the six months before the exhibition to discuss how best to develop the collaborative proposal.

The group opts to call the large project *Paradise 8*. The gallery is divided into eight independent spaces. Each project has its own concept, complete with subtitles and lists of participating artists.

▢

... or... a rejected suggestion for the press release (excerpt)

Pip Day
December 1998
Paradise 8 at Exit Art
Opening January 16 to April 1999

Paradise 8

Eight curators come together for three months to explore and present a series of hypotheses, of works-in-progress. The eight initially distinct zones within the space will shift, meld, and/or mutate over the course of the three months according to the shifts, melds, and mutations of ideas.

▢

The "initially distinct zones" remained mostly distinct for the duration of the exhibition. Each curator pursued her or his particular proposal, myself included. In this respect, Exit Art's larger goal failed. The nature of the final exhibitions was not collaborative at all. But the curators did attempt to incorporate some elements of change into their exhibitions over the course of the show.

My personal response to Exit Art's proposal was to give evidence of my three initial impulses. The first was to build on a concept that I had been working on, in a smaller scale: to challenge the idea of completion. To uproot the notion of the "definitive" exhibition, which is generally central to established curatorial

procedure, I had been redoing shows for some time. Exit Art seemed the perfect venue in which to reconfigure my past sequential redoings into a unique show. I could review, reassess, and revise the project without having to have recourse to a postscript in the usual form of a written expository text.

I wondered, then, how to develop a "working exhibition" without doing a reveal-the-process type of show? How to start publicly, to replace stasis with kinesis, to transfer the moment of selection and preparation to the temporal and physical space of the exhibition itself, to make the process of developing an exhibition an interesting and viable model for a show?

To avoid the *ta-dah* of opening night, I would "grow a project" in public. I looked for a prefabricated framework whose inherent structure would allow me to start the show with an unfinished product.

This search led me to both my second and my third impulses. I decided to give this framework the shape of a practically empty archive. This borrowed structure would provide me with the opportunity to receive input over the course of the show, and to allow the show to modify itself accordingly. The structure would also allow me to distance myself technically from a typical curatorial position, to give up some control over the outcome(s) of the project. I had become increasingly interested in reasserting my role as catalyzer, as filter or conveyor of information, as one who can read, reflect on, and present the work being made around me, and in reassessing my position as "selector." The archive would then act as the locale where a number of conversations could be generated, as a point for the exchange of information, and as a structure that could support and, importantly, *display* this transmission game. It could function simultaneously as a public and a private space.

I came to resolve my third, very subjective impulse by adopting the metaphor of the faucet as the conceptual drive for the project. I wanted to focus on the tap as the device that activates an entire system of exchange between public and private.[1] This system of exchange came to be the fundamental concern of my project.[2]

The archive seemed able to embody that metaphor, and the metaphor wrapped itself around the physical support.

So, I called my project *Faucet*.

In *Faucet*, my "zone," or proposal, within *Paradise 8*, the mutation I sought happened internally.

Faucet incorporated change directly into its structure.

1 Mexico City, summer 1996: when you're new in town, you don't put your toothbrush under the tap.

2 I should also mention here that I had recently seen a collaborative video work by Daniel Guzman and Luis Felipe Ortega that addressed issues regarding the circulation of information. It was an ideal launching pad for the show.

◻ ◻ ◻ ◻ ◻

Context/Archive

The archiving system in *Faucet* democratizes somewhat the traditional curatorial practice of connoisseurship, of authoritative judgment of the art product. The various forms of submissions to *Faucet* are treated simply as conduits of information, and are archived solely according to their format and the order in which they are received. A catalogue or a book is treated as a form of transmitting information, one that can enter into dialogue readily with a visual one, or with a finished artwork in the space. No work is rejected from the archive.

◻

Keepers, Markers, Submission Forms, numerical locations, and guides keep the system functioning smoothly.

Examples of submission form, keeper, and marker as submitted to Faucet. Courtesy Pip Day.

◻

The archive or "lab" was conceived as an essay; a book; a slide carousel; a video; an installation; a photo; a scrap of paper; a story that my brother, the biochemist, would write. Artists, writers, computer programmers, the guy I sat beside on the plane, mathematicians, and curators were invited to contribute to *Faucet*, sometimes in the form of works "added" to the show, sometimes as comments or notes or essays. The continuous and varied influx of information shaped the archive. It became an archive of the present, an idea in formation, complete with addenda and errata. I held office hours once a week to review proposals, to record results from the "lab," to archive, to talk with artists and visitors, and to make notes

about the formation of *Faucet*. The physical space became a sort of well — a place where people gathered to exchange gossip, news, and more, and to draw water.

The growing reservoir of narratives about *systems of circulation* took form according to the submissions gathered and received. I also took the liberty of inviting individuals to contribute to the project to shift the trajectory when I felt that it was focusing too tightly or repetitively on one area of investigation.

The themes most commonly addressed revolved around my proposed subject of the public and private exchange and circulation of information. They fell loosely into the following categories:

- technology's facilitation of new forms and systems of exchange
- the recycling of materials, reemployment of borrowed sources, building of wholes from fragments
- urban space, including refuse, contamination, the danger inherent in social interaction
- memory as a physical structure or system put in place for various types of recall
- strategies related to the gathering of information, including clinical-like and "objective" reporters
- the telling of stories and the creation of contemporary mythologies

Other projects only tangentially touched on the proposed conceptual framework for *Faucet*.

□

New York City-based artist Dave Herman of DHLabs made submission MISC-012 to *Faucet* on February 2, 1999. He presented me with an architectural blueprint indicating how he would restructure the existing archive to provide a better, more precise system for users. Dave moved his office into the gallery and commenced his "performance" and reshaping of the space shortly thereafter. He occupied his office for several hours a day, reworking my method for receiving and processing submissions, providing suggestions on typewritten While-You-Were-Out message paper for me to consider.

*Dave Herman's DHLabs 1999, detail.
Courtesy Pip Day.*

◻ ◻ ◻ ◻ ◻

Think about brushing your teeth.
Think about rethinking brushing your teeth.

Contract

The underlying premise of *Faucet* is to engage a contract between artist and curator to work in parallel toward an unknown narrative or narratives, built over the duration of the project.

The word faucet is used as a sort of metaphor for systems◼ at play in the city, for urban structures✛ of circulation.[1] Some invisible, some revealed. The faucet is the tool, the point of departure for interaction between these realms and systems. It is the contact point between interior and exterior. It provides evidence of that communication. The presence of the faucet implies both the individual or private, and the social or public: it requires an act, a human hand to activate the gathering, sifting, and discharge of substances: from the faucet comes the water,* water flows into the sink,° it is stopped. Then released by the plug,✦ it passes out through the drain,▲ and this is the last we see of it.

This urban metaphor will likely expand to encompass a larger analysis of systems of circulation; physical, intellectual, virtual. This conceptual source will generate the project; from here, the initial submissions should spring, or the submissions should address themselves. As the show begins to develop, the framework will likely branch into multiple areas of investigation.

1 *Faucet* could easily have led to an analysis of the body as system, but I, and the submissions received, chose to explore the exchange of information as system. There is a certain harmony of structure and action in the plumbing analogy.

◧ Tap and drain. Intake and output. Influx/outpouring/recycling of information.

✛ What exists prefaucet? Emergence from the city — the flow through the pipes, through unseen, underground, behind the walls, urban structures. Postdrain: the return to the city.

* *the water:* A moment of visibility. Hot and cold ... soothes, scalds, freezes ... drips and tortures ... rinsed and cleansed ...or contaminated.

° *sink theory:* My brother tells me a biological story/theory about rats and underpopulated and overpopulated urban centres: If there are too few rats enclosed in a space, the dominant male rat will kill off all the other males. The rats will eventually die. If a space is overpopulated with rats, the dominant male will again kill all the other male and female rats. He compares this situation to overpopulated, disease, and crime-ridden megalopolises. Melting pot. Mixing bowl.

✦ *the plug:* Between boundary & boundlessness ... the politics of imagination.

▲ *the drain:* Excrement ... the elbow in the drain keeps the smells from returning back up the pipes.

□

Day 1: The space contains a desk, a call for submissions, and a filing system with instructions for use. The conceptual and structural plumbing is in place.

On a monitor on top of the filing cabinet is running AW-001: Jose Felipe Ortega and Daniel Guzman's *Remake* (video, 1994). The piece consists of several segments in which the two Mexican artists "remade" seminal conceptual-video pieces from the late 1960s and early 1970s based on descriptions of the works the artists had read in books and magazines. They had never viewed the original videos.

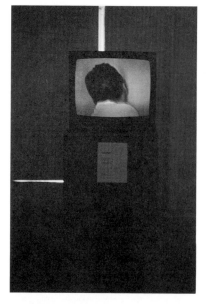

Jose Felipe Ortega and Daniel Guzman's Remake *(1994), as installed in* Faucet. Courtesy Pip Day.

□ □ □ □ □

In every first-world city, there is always someone to boast
that their drinking water is the cleanest of any city in the world.

Process

Submissions of ideas for the project are encouraged and are accepted at the front desk throughout the three months. Please feel free to submit suggestions, criticisms, responses to specific or general issues already present in the space, or new ideas regarding systems of circulation. Submissions can take the form of notes, essays, slides, photocopies, books, videos, or proposals for projects, some of which are realized in the space, depending on feasibility (budget and space). Please note, all submissions, whatever their form, enter the archive and are available for use by the public. *All submissions must be accompanied by a registration form.*

□

From: Anton Vidokle
To: Pip Day
Subject: Re: hello

good morning pip,

i had a weird dream: i was in india at some old monastery that was run by a fashionable guru. i told him that he was full of shit and he started crying. funny, huh?

i am excited about doing something with you at colo's place. i am unsure if my contribution should be artistic or curatorial, but i got this idea: i would like to show all the artworks my parents have. it's a very strange accumulation, a kind of an accidental collection that includes:

1. a couple of copies of Japanese prints,

2. very strange fairy-tale paintings on silk by a Russian theatre-set designer.

3. two watercolours of an unknown American artist depicting cliché scenes

4. some b/w prints of Dutch cityscapes

5. a still life with fruit and a small abstraction painted by me in the first year in college

6. a representation of madonna (not Madonna) made in georgia (not Georgia); it's a metal relief or it's hammered or something

7. a figure of a man playing a balalaika made of straw in black lacquered background

and some other small things.

the presentation would be called The Collection of Mr. and Mrs. Vidokle

what do you think?

anton[1]

This project developed into AW-022: *Anton Vidokle's Selections from the Collection of Lev and Valentina Vidokle, a selection of watercolours, oil paintings, and prints from the art collection of Lev and Valentina Vidokle, 1999.*

❑

Again and again, visitors, artists, curators asked me if I was functioning in the capacity of "artist" for this project. I chose

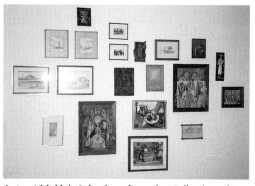

Anton Vidokle's Selections from the Collection of Lev and Valentina Vidokle, *1999, as installed in* Faucet. Courtesy Pip Day.

not to determine the boundary between artist and curator. By attempting to make myself less visible as a "force" in the project, I had become more so. The audience needed me to define myself. This troubled me.[2]

1 E-mail received from Anton Vidokle on February 21, 1999.

2 I decided to ask an artist, Anton Vidokle, and a curator, Gilbert Vicario, to make contributions to the project: both of their creative processes hover somewhere in the zone between curator and artist. Later, I asked curator Barbara Clausen to contribute. She chose to organize an event, a film screening in which she used the films as raw material to reengage the spatial and temporal concerns of the space.

▢ ▢ ▢ ▢ ▢

Some *Faucet* Proposals/Projects

Although listed below is a selection that attempts to represent the diversity of the proposals submitted to *Faucet*, this list also represents an act of singling out, of *choice* of some of those submissions the curator found most interesting, challenging, insightful; those that propelled the larger project in unexpected directions. This choice is precisely what *Faucet* had aimed to avoid. Nevertheless, the submissions are listed chronologically according to when they were received into the archive.

▢

the 7 LEVELS OF GARBAGE

It is said that in Mexico city all garbage goes through 7 stages of sifting from the moment it is thrown on the street until its final destination at the garbage dump outside the city. A hierarchy within the different gar- bage collectors has formed along those 7 levels . On the night of the fourth of feb,1994, I put 7 failed bronze sculptures (identical but painted 7 distinct colors) in 7 different bags of garbage and dropped them in the garbage piles in 7 districts of Mexico city. In the following days ,months ,years ,1 wandered through flea markets in the city looking for the sculptu- res to resurface . As for now I found 2 of 7 .

Francis Alÿs, Mexico, D.F., Feb '94

Francis Alÿs's The 7 Levels of Garbage, *1994, photo, paperclipped onto typewritten text, as submitted to the archive in* Faucet. *Courtesy Francis Alÿs and Pip Day.*

A-005: Francis Alÿs's *The 7 Levels of Garbage*, a photocopied text (describing the project), a clipped photograph, a laser copy, 1994.

The text read: "*7 Levels (or lives) of Garbage* happened in Mexico City in the month of February 1994 and was an attempt to follow the derive of 7 objects in a megalopolis; as well as an intent to infiltrate alternative systems of exchange and circulation of commodities into a city's vernacular organization."[1]

F-006: Bruce Ferguson's *Going for Baroque*, video, 1996. "A long, rhyming-couplet poem regarding art and theory as a response to the Mexican artists who are 'redoing' Bruce Nauman's tapes."[2] This twenty-minute tape was made as Bruce's participation in a confer- ence which he opted to attend in this video format. It is filed with the other videos in the filing cabinet below the monitor. The audience is free to choose and play videos in this cabinet.

A-010: Mara Jayne Miller's *Faucet, Tap, Spigot, Cock*, a reading (not naming) what comes out and into circulation, a three-page essay, a reading of the project *Faucet* at Exit Art, 1999. This essay poses and addresses the question, among others, "Who controls what comes out of the faucet? (including: can you make it stop dripping?)"[3]

Faucet, installation view, April 1999. Courtesy Pip Day.

SLIDE PROJECTION 015: Gilbert Vicario's *Fountain 31 Views*, a curatorial slide project consisting of thirty-one slides of photographs of Marcel Duchamp. "*Fountain-31 Views* was organized on February 23, 1999, at approximately 3:12 p.m. in the slide library of the Philadelphia Museum of Art. Beginning with a repository of over three hundred slides which document both works of art and archival photographs by MD [Marcel Duchamp], a curatorial selection process was established approximately four minutes after beginning which systematically rejected artistic output in favour of documentary narrative. Twenty minutes later a body of images began to take shape which seemed to address perfunctory questions pertaining to taste, access, and superficiality within the condition of a sexual/scatological framework. The images that I have chosen illustrate various aspects of MD's life from his early years as a dada prankster with shaving cream horns, to a photograph of his first wife, to the obligatory references to chance and gamesmanship. On a modernist level, these images reveal and conceal conceptual undercurrents of repetition and reproduction through their chronological and biographical sequence. Instead, by focusing on the social condition, these documentary images tease out a multiplicity of associations-alliances-couplings, invite speculation, and confirm assumptions. In this sense, *Fountain* links the contract of *Faucet* with a compatible yet polemic system premised on the metaphor of contamination, urine, feces, which consistently raises the stakes on the inherently social act of circulation and interaction."[4]

EVENT-019: Barbara Clausen's film screening on March 10, 1999. A screening of experimental films from the 1960s and 1970s. Clausen's selection of films was based on the statement in Noel Burch's *Spatial and Temporal Articulations*: "Formally a film consists of a succession of fragments excerpted from a spatial and temporal continuum."[5] The films were projected on different walls within the space — the audience was required to reposition themselves to view each projection.

1 Francis Alÿs's description of the project submitted to *Faucet* on January 26, 1999.

2 Bruce Ferguson's description of the project submitted to *Faucet* on January 26, 1999.

3 Excerpt from Mara Jayne Miller's essay submitted to *Faucet* on February 2, 1999.

4 Gilbert Vicario's description of the project submitted to *Faucet* on February 24, 1999.

5 Excerpt from Barbara Clausen's description of the project submitted to *Faucet* on February 24, 1999.

Postscript

New York City, September, 2001. Now no system is taken for granted, and we begin to feel the urgency of informing ourselves about the basics. We try to visualize and track those unseen urban structures and systems like plumbing, the postal service, the subway lines, telephone lines, media circuits.

DOROTHEE RICHTER is a curator, art historian, and author. She was curator of *female coalities*, an international project with lectures and exhibitions by Ute Meta Bauer, Eva Meyer, Alison Knowles, Marion von Osten, Valie Export, and others (1996, Bremen). She was curator with Barnaby Drabble of an international curators' symposium on art as intervention, art and social critique, and art as service, called "Curating Degree Zero." This symposium was held in Bremen in 1998, and was published by the Verlag fuer moderne Kunst, Nuremberg. Richter was the curator of "Dialoge und Debatten, Dialogues and Debates," an international symposium on feminist positions in contemporary visual arts in 1999, the results of which were also published by the Verlag fuer moderne Kunst, Nuremberg. Richter lectured at the University of Bremen, Germany from 1998 to 1999. Since 1999, she has been artistic director of the KunstlerHaus in Bremen and doing research on Fluxus. In January 2003, there will be a follow up to the symposium on critical curating in Basel, Switzerland "Curating Degree Zero/ 2," which will be curated by Dorothee Richter and Barnaby Drabble.

◻

Confessions

DOROTHEE RICHTER
(TRANSLATION BY BARBARA VANDERLINDEN)

FIRST OF ALL, I WOULD LIKE TO INTRODUCE False-Hearted Fanny, a character I have borrowed from Emmett Williams, a Fluxus artist whom I respect highly.[1] False-Hearted Fanny will be the one who poses the questions, makes interjections, questions in general a certain depiction of curating, and makes my existence as a fragmentary subject easier in every respect.

FALSE-HEARTED FANNY: Because I was borrowed from the play, I may as well bring the opening sentence along: "As the curtain rises, or opens, or whatever the case may be."[2]

DOROTHEE RICHTER: You are alluding to the fact that everything we do as actors in the cultural sphere takes place "on stage," as it were, even when representing a particular position in an article.

This place, any place where cultural statements are made, whether in the context of a publication or within a white cube, is a central place of action whose structural composition is very interesting to explore. Elsewhere I have already shown that the roles of the artist and curator, as actors who perform in those sites, overlap. I say this even though I am aware there are differences between these roles. These places where art is "put on view," or where art is negotiated, I would like to define more precisely by using the Lacanian concept of the *tableau*. This tableau, a blank surface for projection, takes on an important function

in the visual arts, the function of putting on view, but also the role of the opaque surface that conceals relationships. It seems to me that this place has similarities of constitution and structure with a place of intrapersonal development of the sort Lacan describes.

According to Lacan, in the mirror stage, a child develops an imagined idea of a unity of the subject that must always be confirmed by an Other.[3] The child sees himself in a mirror for the first time and responds with joy. The child sees himself from outside, as it were, as a whole, a self-contained form. At the same time, he turns to his mother, or the person holding him, seeking confirmation of this recognition. The gaze of the mother confirms him in his whole form. As Sigrid Adorf comments: "[Lacan's] central critique begins with the elimination of precisely this view in the construction of a self-reflexive consciousness that locates itself in the field of vision according to central perspective."[4] The subject remains dependent on a confirmation from outside, but refuses to realize this; he wants to be understood as a seeing subject only.

Lacan makes this intersection of perspectives clear by using two overlapping triangles in his theory. As S. Adorf explains:

> Lacan opposes the geometric optics of central perspective, in which the subject is located at the point of the eye, with a second triangle that corresponds to the perspective of the Other that is inaccessible to the subject — the view from outside — which Lacan connects not with the (real) existence of an Other but with a point of light. From the perspective of the point of light, of the (imagined) view from outside, the subject can no longer be assigned to a point but is instead represented by a line that Lacan calls a 'tableau.'[5]

On this tableau, this screen, the subject delineates itself. Every self-presentation necessarily becomes a game with this screen on which the widest possible number of delineations are on view. At the same time, it develops a kind of courting for the gaze from outside, a reified gaze, as it were, the gaze as "object small a."[6]

Every exhibition, every positioning in the field of the visual arts, is based on this relationship of desire, this courting of the gaze from outside.

FHF: But isn't it somewhat risky to take an intrapersonal agency and situate it outside oneself, in real space, to such an extent?

DR: Even intrapersonal agencies have their effects, their visible effects in real space; moreover, I am speaking of structural similarities. In any case, this conception offers a good explanation for several phenomena in institutions. There is a kind of tactics of mirroring. The exhibition space might look nice, but backstage spaces can be filthy and in complete disorder (cellars, storage areas). This contrast always seems strange to me. The opacity extends not only to the real space, but also to the exhibition policies and power relationships. It all boils down to who decides what to buy, who cleans the toilets, who decides the budget, and so on.

FHF: I recall a story the Guerrilla Girls told about an art dealer:

> Pat Hearn, a trendy art dealer, approached us a few years back and asked if we were interested in doing an installation for her gallery. We kicked the idea around but were pretty much split on the issue of participating in a commercial system that is discriminating to the extreme. It seemed like sleeping with the enemy. So we made her an offer she had to refuse. We proposed a show about the situation of women and artists of color in her gallery. She would have to open her books so we could compare their sales prices. We promised not to mention names, just gender and race. "How interesting, how radical," she cooed. "Let me think about it and get right back to you." We never heard from her again. — Gertrude Stein.[7]

Sometimes the will to make things public will only go so far.

DR: To break things up in my role as curator, I have held theory-related events in the gallery's office or invited artists who have a studio in the KünstlerHaus Bremen (where I am curator) to design furniture for events. Such things are, of course, approaches that contain some degree of failure.

Even with the international artists I invite, I prefer projects that are very experimental and that play with levels of visibility.

For example, the artist Jeanne van Heeswijk initiated a project in which musicians from Bremen where invited to bring their pieces by the KünstlerHaus or to record them there. Then on a certain day, there

was a little buffet table and an opportunity to meet informally in the KünstlerHaus, exclusively for the participating musicians (the first level of public exposure). In the end, forty works were performed; in one case, we supported the production of a piece. There were classical works, a hip-hop song, a Turkish group, jazz, a reading, a song from a musical.

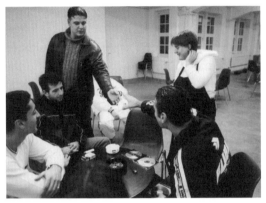

A CD was produced that has the individual works as well as a superimposition of all the pieces (the second level of public exposure).

For the "exhibition," the gallery space was filled with the mix of the pieces (the third level of public exposure).

Krach schlagen (Make a racket), *art project by Jeanne van Heeswijk, KünstlerHaus Bremen, 2000 (meeting of the musicians). Photo by Frank Pusch.*

The CD and the sound installation tried to be a kind of historical cross-section of the sounds produced on a certain day in a certain city. The project also referred to the Grimm brothers' fairy tale "The Bremen Town Musicians," which tells of four old, useless animals who sing together to drive robbers out of a house and who then take over the house for themselves. In a metaphorical sense, Jeanne van Heeswijk wanted to claim for art the status of something that was purposeless and without any entertainment value or event culture, of something without any claim to social utility. The resulting noise of the installation — and it was loud — emptied the room at first. I ask the reader to imagine an earsplitting noise. This project was part of that year's program called *Urban Neighborhoods*, which included both art projects and lectures. The focus was on including concrete (that is, historical) contexts of the specific site, because I suspect that "urbanism" is a metaphor often used to cast a veil over things and strip them of their history.

FHF: "Il n'y a pas de hors texte."[8]

DR: Right, there is no outside of the text, no outside of the discourse. And I do not wish to construct a contrary position to this statement, but it seems important for me to take a particular position within the discourse. I am referring to Derrida's concept of the text: "What I call

text is practically everything. It is everything — that is, there is a text as soon as there is a trace, a differential reference from one trace to the other ... The text is not, therefore, limited to the written, to that which is called writing as opposed to speech. The speech is a text, the gesture is a text, the reality is a text in this new sense."[9] But for that reason, it is not a matter of indifference which position I take as a curator or as an artist; it always has political implications. Therefore, I have never seen it as my task to present the positions of individual artists. This kind of presentation is done extensively elsewhere, and it is closely related to the notion of the artist as genius. I'm skeptical of that notion, because I see the product of art as a product of discourse. For these reasons, I have frequently worked with other curators or been involved in exchanges with them (including Ulrike Kremeier, Eva Schmidt, Barnaby Drabble, Nina Montmann, and Stella Rollig). By doing so, I am attempting to keep the discursive aspect of the work open, even toward the outside, and to enter into the process myself, to question my own positions.

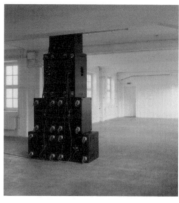

Krach schlagen (Make a racket), *art project by Jeanne van Heeswijk, KünstlerHaus Bremen, 2000 (view of installation). Photo by Joachim Fliegner.*

FHF: All these well-intentioned political ambitions in the contemporary visual arts seem suspect to me. It paints too rosy a picture. "We are all ridiculously kind people," as Dostoyevsky had his Hippolyte say.[10]

DR: There is a risk that ideologies, even those behind a political claim for art, do conceal mechanisms of power. Curators, moreover, are subject to their share of narcissism. Even so, when I work with resistance and discourse theory, I am speaking of a subject that is not conceived as a reductionist subject, as an insubstantial, grammatical figure in Judith Butler's sense, but I am instead following the ideas of Foucault, who characterized the body and its desires as supports for resistance, and who thus thinks of the body as the material basis for inscriptions of power relations and resistances.[11] In my opinion, this standpoint brings us back to the concrete situations of concrete bodies/subjects; that is, back to constellations of power that work within the art world, such

as the relationship of artist to curator, cultural politics, hierarchies among institutions, hierarchies within institutions, and so on. And yet this way of looking at things provides ways to formulate a revolutionary potential within society through the visual arts. Foucault wrote:

> There is no single locus of great Refusal, no soul of revolt, source of all rebellions, or pure law of the revolutionary. Instead there is a plurality of resistances, each of them a special case: resistances that are possible, necessary, improbable; others that are spontaneous, savage, solitary, concerted, rampant, or violent; still others that are quick to compromise, interested, or sacrificial; by definition, they can only exist in the strategic field of power relations. But this does not mean that they are only a reaction or rebound, forming with respect to the basic domination an underside that is in the end always passive, doomed to perpetual defeat.[12]

Situating this potential for resistance within visual art is my goal here.

The project I would like to discuss was conceived by a collaboration of three artists. Achim Bitter and Korpys/Löffler (Korpys/Löffler always work together) filled the exhibition space with objects they had found in the storage spaces or in use in the art institutions, galleries, and museums of Bremen. These objects included desks, boards, doors, large carpets, and leftovers from installations such as maps, large grey pieces of material, and parts of multiples created by other artists in former exhibitions. Several of the pieces could only be identified on closer examination of their distinctive surfaces. The installation was divided into two parts, following the preexisting structure. The partition wall consisted of doors and boards jammed between the floor and the ceiling; a passageway remained clear. As with bulky trash items waiting to be hauled away, the dominant colour was light brown. In the back part of the space, the relic was stacked to form a grandstand for climbing up to use as a seat to watch a video projected on the partition wall. The video consisted of a compilation showing the construction or destruction of strange spaces. The backstage area at a Wagner opera was also shown, along with excerpts of houses being demolished, humorous scenes from Tati films in which the circumstances devolve into a cheerful chaos, extremely violent excerpts from provocative

political films of the early 1980s, outdated instruction films for do-it-yourselfers, and absurd scenes from old Soviet space capsules. The film loop lasted four hours, so that viewers had the impression that the individual sequences never repeated. The film established connections with the content of the exhibition: the construction and deconstruction of spaces and the concrete possibilities for inter- vention. Tools were strewn in the front part of the room, giving the installation the impression of being disorganized and unfin- ished. This provisional character gave the visitors an opportunity to change the situation. The film excerpts also had formal similar- ities to the situation in the room: they too were overwhelmingly a wood-coloured light brown, pun- ctuated by the pink or bright green found in the installation.

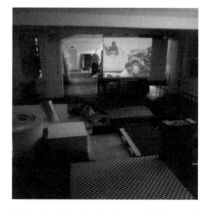

Video installation by Korpys/Löffler and Achim Bitter, KünstlerHaus Bremen, 2000 (view of the installation). Photo by Joachim Fliegner.

On entering the space, the public found itself in a tension-filled situation, as the status of the objects could not be determined imme- diately. The monumentality of the grandstandlike structure suggested the status of an autonomous sculpture, but the structures in the first part of the room seemed temporary. Moreover, drinks were available during the installation, and the sculptural constructions were used as bars. The video shown had scenes of detonation and destruction so intense and gratifying that the effect was stimulating. The possibility of altering the space hung in the air. The public reacted with reserve at first, almost muted, as is the case at many exhibition openings. Then, within a few seconds, during which a wave of relaxation palpably ran through the room, people began to enter the grandstand and use it. The atmosphere changed, became relaxed and stimulated at the same time, and a partylike atmosphere developed. The public was visibly adjusting to the space. This moment of self-empowerment and appro- priation was stirring. It happened through a change in the status of the sculpture, which subtly revealed the place to which auratic, autono- mous works of art normally banish the viewer. At the same time, the

sculpture was a feast for the eyes: the delicate shadings of brown, pink, and bright green, the vertical and horizontal rhythm of light and dark lines and planes.

FHF: Aren't diverse political claims overdone or inappropriate for the visual arts, even when they do function as an installation, event, or object?

DR: From an art history perspective, some artistic statements are closely related to social protests — I need only mention Fluxus or the Situationists. Interestingly, the actions of the Fluxus artists were familiar to a broad spectrum of the public — in Germany, at least — thanks to outraged reviews in the newspapers. Moreover, philosophical, artistic, and political discourses influence one another. The contemporary visual arts are in some respects an elite area in any case; only about three percent of the population is interested. So we aren't going to get any large movements started that way. Nevertheless, the visual arts are certainly not without influence on society by way of their influence on other discourses.

Groups of artists, for example, WochenKlausur (Weekly Exam/ Cloister), try to intervene directly into societal processes by organizing within a few weeks — thanks to conversations with all of the groups involved — such works as a home for drug-addicted women in Zurich or a bus to address the medical needs of the homeless. But even this kind of artistic action is a symbol or, if you will, a signifier in a chain of signifiers. Over the long term, however, this action can influence and revise discourses. It is possible to reclaim for the visual arts what Foucault demanded of philosophy: "Philosophy as activity. The movement by which, not without effort and uncertainty, dreams and illusions, one detaches oneself from what is accepted as true and seeks other rules — that is philosophy. The displacement and transformation of frameworks of thinking, the changing of received values and all the work that has been done to think otherwise, to do something else, to become other than what one is."[13]

FHF: But is this viewpoint anything more than "care of the self"?[14] And where is your sympathy for the other ninety-seven percent?

DR: The sympathy is concrete when I find I can only communicate in a limited way to other people I like — say, a mother from my daughter's kindergarten class — what I do and its significance.

I have, moreover, tried to broaden the spectrum of visitors in the KünstlerHaus Bremen. For example, I curated a symposium on feminist positions in contemporary art. I invited artists, art historians, and curators:

Rineke Dijkstra, Christine and Irene Hohenbüchler, Elke Krystufek, Ute Meta Bauer, the Guerrilla Girls, Beatrice von Bismarck, Sigrid Schade, Ruth Noack, Frauensolidarität/Frauenbeziehungen, Eulalia Valldosera, Eija Lisa Athila, Ursula Biemann, Old Boys Network, and others.[15]

The audience was heterogeneous (and large). Admittedly, this fact also made understanding each other difficult. The audience included young artists, older activists from the women's movement, several professors from wide-ranging fields, and young students inspired by feminism and lesbians. The various discourses did not find a common language. For instance, the art historians spoke too theoretically for the young women to accept them, and the artists asked themselves why their artistic positions should be questioned in terms of political correctness. But it was precisely this political correctness that the more radical groups, like Frauensolidarität/Frauenbeziehungen, demanded. For the more theoretically oriented women, like the art historians and professors, many of the views of young artists in the audience seemed naive.

The young artists, for example, did not think it was obvious that the concept of the artist-genius should be questioned as a paradigm of the white, male art world. The situation was not easy for the moderators. I realized the extent to which the public and several of the speakers saw me (the curator and one of the moderators) as a defining power. I found being placed in that role uncomfortable, because suddenly there were powerful women and powerless women. It was a strange experience, because I have always experienced curating as a kind of self-empowering process. (My first exhibitions consisted entirely of the work of local artists shown in a small gallery of a cultural centre.) Moreover, curating exhibitions is made up of a number of banal activities. Specifically, these activities include contract writing; meetings with artists about projects; meetings with teams responsible for organizing housing, materials, equipment, or with teams responsible for writing programs and press releases; meetings with graphic designers; budget preparation and maintenance. These are activities a curator takes on gradually.

I tried to approach the situation during the symposium appropriately by responding as openly as possible. I explained that my selection of speakers resulted from a discursive process in which others participated, including the group from the university with whom I read texts, the organizers of the scholarship fund for artists, the organizers of the site for the event, and the other curators with whom I exchanged

information via print media and the Internet. I also tried to clarify that I did not claim to have made a universally "correct" selection. In retrospect, however, I am uncertain of the result. The symposium and the discussion would probably have been more focused if the positions of the presenters had been more closely aligned. I also con-

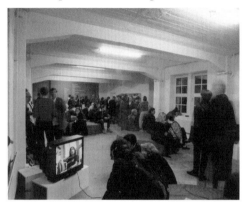

sidered it programmatically important to allow the widest possible range of participants in the visual arts to have their say, so that criticism and influence could come out in the open. One possibility would have been to define feminism more narrowly, only inviting presenters who explicitly and deliberately characterize themselves as feminists. But that too struck me as too narrow a restriction, because women artists more often have difficulty characterizing themselves explicitly as feminists: they are at greater risk of marginalization within the "operating system" of art than are those art historians who have managed to establish feminist institutes, or at least gender studies, at several universities. The audience also expressed a desire to have more time for discussion. That might have brought the debate to a head, but the difficulties of understanding different discursive formations would have remained.

Materialien (Materials), *a temporary archive, KünstlerHaus Bremen, 1999 (view of the installation). Photo by Frank Pusch.*

There was also a palpable need for the public to experience events that probed feminist approaches within professional contexts, and thus situated those approaches historically, as well as a need to take up the feminist debate on the level of a professional actor in the visual arts.

The second part of the project consisted of an exhibition in the KünstlerHaus Bremen. (The symposium was named "Dialoge und Debatten — Dialogues and Debates," the exhibition: *Materialien/ Materials.*) Each speaker was asked to name artistic, art historical, or curatorial positions relating to feminism in the contemporary visual arts that they considered important. The catalogues, books, CDs, videos, and Web addresses of the sixty artists, art historians, and curators who were proposed, plus materials from each of the speakers, were placed in folders on an open shelf as a living, temporary, and ephemeral

archive. The exhibition space had large, round pillows where visitors could sit to comfortably use the equipment, video monitors, CD players, and computers, as well as small, round tables where visitors could look at catalogues or talk. All of the names of those involved in the project were written on the far wall as a visible representation.

The exhibition was extremely well attended. To my astonishment, roughly half the visitors were male, although the symposium visitors were almost exclusively female. The public enthusiastically examined the catalogues, videos, and CDs. Above all, the material and space were used as opportunities to communicate. Many visitors came several times to examine the materials more closely. The exhibition seemed to address a hunger for representation. At the same time, I suspect that it was important that the representation of women working in the visual arts was not presented from a sociological perspective or as a deficit, but rather under the sign of the operating system of art and within it in terms of references and interests. The material was distinguished by an astonishing heterogeneity. The artists included the younger and less well known (Fenja Brater, Sandra Satori) as well as the famous (Gilian Wearing); critics and curators such as Laura Cottingham and Ute Meta Bauer; and theoreticians Abigail Solomon-Godeaux. Only one of the artists declined to be part of a feminist context. The hunger for female representation that I felt from the public almost pained me. Making feminist positions visible, putting them *en tableau*, is an important aspect of my work.

Later in 2001, I worked with Sigrid Adorf and Kathrin Heinz of the Zentrum für feministische Studien of the Universität Bremen to offer a small symposium focusing on art history entitled "Im (Be)Griff des Bildes" (In the Clutches/Concept of the Image). This symposium was more traditional in structure, as "Dialogues and Debates" was, with an accompanying exhibition. But I continue to be interested in forms that depart from the traditional canon of exhibitions. I have the impression that women artists in particular are interested in experimenting. For example, for September 2001, I invited a Dutch group, De Geuzen (whom I had seen at the Manifesta in Ljubljana). The three of them — an artist, an art historian, and a designer — organize an independent exhibition space in Amsterdam, and design projects that recall the playful character of Fluxus events but nevertheless manage to undermine traditional categories and representations. (See www.geuzen.org.)

FHF: In your theoretical references, you mention Michel Foucault, Roland Barthes, Jacques Lacan, and Sigrid Schade repeatedly. The concepts for projects and the invitation cards are heavily laden with theory. What do you think of Robert Hughes's claim that "jargon, native or imported, is always with us; and in America, both academe and the art world prefer the French kind, a thick prophylactic against understanding? We are now surfeited with mini-Lacans and mock Foucaults"?[16] Is the hype of theory already passé?

Materialien *(Materials)*, a temporary archive, *KünstlerHaus Bremen, 1999 (view of the installation).* Photo by Frank Pusch.

DR: It is difficult to say how Hughes tried to fathom these complicated texts. It does indeed require some effort to engage intensively with theoretical concepts. I find it more exhilarating to read these texts together with other people, because within a group, a theory's possibilities can be probed more deeply through discussion. It has been, and still is, important for my curatorial work to observe artistic and curatorial positions from a structural perspective, and to judge current trends from a critical distance. It was always important for me to develop a theoretical position that is skeptical of the paradigms of the art world, such as the concept of the individual artistic genius, the autonomous work, the market orientation of works, and the supposed opposition of everyday life and art.

The concept of the *pictorial turn*, which is trendy these days, is usually meant to postulate a return to the visual in contrast to semiotic analysis. To a certain extent, however, the concept conceals the fact that, from the beginning, the visual element played an important but analyzable role in semiotic theory. Saussure demonstrates, for example, that linguistic expressions do not characterize things directly, but that signs always combine a phonetic image and a conceptual image. All systems of signs are oriented toward the image from the start. In contemporary art in particular, visual representations are composed of superimposed systems of signs (image, installation, commentary, the

work with various media, and more). All these reflections do not, however, exclude the possibility that for my curatorial practice the pleasure of viewing is an essential, intense, and sometimes ecstatic activity.

FHF: We have already exceeded the proposed length: "The piano falls. Then the curtain falls, or closes, or whatever the case may be."[17]

1 Emmett Williams, *My Life in Flux and Vice Versa* (Stuttgart and London: Edition Hansjörg Mayer, 1991), 335.

2 Ibid.

3 The passage concurs with remarks in Sigrid Adorf, "Ein-Blick in die helle Kammer: Claude Cahuns fotografische Selbstinszenierung" (master's thesis, Universität Bremen, 1997).

4 Ibid., 19.

5 Ibid., 20.

6 For detailed explanation of the Lacanian term "object small a" in relation to the visual field see: Margret Iversen, "What is a Photograph?" *Art History* 17, no. 3: (September 1994), and Jacqueline Rose, *Sexuality in the Field of Vision.* This paragraph is based on my introduction to *Curating Degree Zero*, in which I tried to analyze the changing roles of curators as one of the new participants in the world of the visual arts and artists: Dorothee Richter, "Einführung / Introduction" in Richter et al., ed., *Curating Degree Zero: Ein internationales Kuratorensymposium / An International Curators' Symposium* (Nuremberg: Verlag für Moderne Kunst, 1999).

7 *Confessions of the Guerrilla Girls* (New York: HarperPerennial, 1995), 22. The Guerilla Girls use pseudonyms, borrowed from famous women of the past.

8 Jacques Derrida, *Of Grammatology* (Baltimore: Johns Hopkins University Press, 1976), 158.

9 Excerpt from a conversation between Jacques Derrida and Peter Engelmann, cited in Peter Engelmann, "Jacques Derridas Randgänge der Philosophie," in Jeff Bernard, *Semiotica Austriaca* (Vienna: ÖGS, 1987), 107 ff.

10 Fyodor Dostoyevsky, *The Idiot*, trans. Henry and Olga Carlisle (New York: Signet, 1969), 306.

11 I am referring here to remarks made by Christine Hauskeller, *Das paradoxe Subjekt: Unterwerfung und Widerstand bei Judith Butler und Michel Foucault* (Tübingen: Edition diskord, 2000), 178 ff.

12 Michel Foucault, "An Introduction," in *The History of Sexuality* (Vol. 1), trans. Robert Hurley (New York: Vintage Books, 1980), 95-96.

13 Interview of Michel Foucault by Christian Delacampagne originally appeared anonymously in *Le Monde*, April 6-7, 1980; translated by Alan Sheridan as "The Masked Philosopher," in Foucault, *Ethics: Subjectivity and Truth* (New York: New Press, 1997), 327.

14 Refers to a title of the third volume of Foucault's *History of Sexuality.*

15 The symposium was accompanied by a publication with essays by the participants: Dorothee Richter et al., ed., *Dialoge und Debatten: Ein Symposium zu feministischen Positionen in der zeitgenössischen bildenden Kunst / Dialogues and Debates: A Symposium on Feminist Positions in Contemporary Visual Arts* (Nuremberg: Verlag für Moderne Kunst, 2000).

16 Robert Hughes, *Nothing If Not Critical: Selected Essays on Art and Artists* (New York: Knopf, 1990), 377.

17 Williams, *My Life in Flux and Vice Versa*, 335.

JOSHUA DECTER is a curator and writer living in New York. His exhibition projects include: *Tele[visions]* (Kunsthalle Vienna, 2001–02); *Transmute* (The Museum of Contemporary Art, Chicago, 1999); *Heaven: Public View/Private View* (PS1, 1998); *Exterminating Angel* (Galerie Ghislaine Hussenot, Paris, 1998); *Cathode Ray Clinic #1* (Apex Art, New York, 1997); *a/drift* (The Center for Curatorial Studies Museum, Bard, 1997); *Screen* (Friedrich Petzel Gallery, New York, 1996); *Don't Look Now* (Thread Waxing Space, New York, 1994). Decter's writings have been widely published in magazines such as *Artforum, Flash Art, Purple Prose*, and *NU*. He has also authored catalogue texts for institutions such as the Magasin, Grenoble; The Photographers Gallery, London; CAPC Musée d'Art Contemporain de Bordeaux; The Carnegie Museum of Art (Carnegie International 1999–00); Kunstmuseum Bonn; Kunstverein in Hamburg; São Paulo Bienal; Secession, Vienna; Museum of Contemporary Art, Tokyo; and Rooseum, Malmo. "Synergy Museum" appears in the book, *The Discursive Museum*, (Hatje Cantz/MAK). He is a faculty member at the School of Visual Arts in New York, and has also taught at UCLA, Art Center College of Design/Pasadena, Konstfack in Stockholm, the School of the Art Institute of Chicago, and the Bezalel Academy in Jerusalem/Tel Aviv.

□

At the Verge of ...
Curatorial Transparency

JOSHUA DECTER

THIS WRITING COMMENCED in the early summer of 2001, at my family's summerhouse, about one hundred miles from New York City. Eventually, the final days of October arrived, and I recall working on a rewrite of the text in a hotel room, somewhere in the centre of Stockholm, at the edge of my cultural bearings. One late afternoon, while reconstructing this very sentence, I observed, through my hotel room windows, clouds moving in and out of the sky, and heard an accelerating wind. Rain was expected the next day. Swedish television played softly in the background.

For most of that October, I was in Europe, an itinerant art professional: the first two weeks installing and opening my *Tele[visions]* exhibition at the Kunsthalle Vienna, and these last two conducting a graduate seminar for curatorial students at the Konstfack art school, in the capital of Sweden. This wandering mode of existence is at once exhilarating and enervating, an oddly familiar oscillation between inspiration and doubt. Fundamentally, though, I am always looking for what might be described as curatorial inspiration, something that will trigger development and articulation of the next project. And there must always be a next project, right?

After teaching in Stockholm, I returned home to New York City, and attempted to reorient myself. Just a little over one month earlier, on September 11, like so many New Yorkers, I had witnessed the destruction of the World Trade

Center. That sunny morning, I watched it unfold from my apartment balcony, just twenty-five blocks from what has become known as Ground Zero. My head shifted back and forth between the TV and the scene, one hand on the remote control, and the other clutching a camera. There was no distinguishing reality from fantasy during those moments, and most perceptual bearings were lost. Strangely, the transmitted images from television were believable, but from my balcony the scene appeared to be an utter confection, a special effect, that would not jibe with my tangible world. Ironically, it was easier to accept the "reality" of the situation via TV; the box provided the ultimately false reassurance, even psychological protection, of continuous mediation, objectification, and distance.

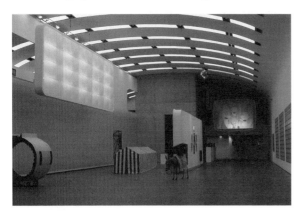

Tele[visions], Kunsthalle Vienna, October 18, 2001 – January 6, 2002. Copyright and courtesy Kunsthalle Vienna. Photo by Joshua Decter.

Perhaps not ironically, in the television interviews that were conducted with me by ORF (Austria's national TV) regarding Tele[visions] at the Kunsthalle, a project that reconsiders how artists have articulated a relationship to TV over the past thirty or so years, I was invariably asked about what it was like in New York on September 11. These interviews were televised on ORF during my stay in Vienna, which somehow functioned to collapse the space between my residual trauma from the terrorist attacks, and the artificial space of my exhibition project. Satellite television was incorporated into the architectural design of the exhibition itself, creating the opportunity for my televisual presence to enter the show, in a most uncanny fashion.

Travelling through Europe following the terrorist attacks, I experienced life at the edge of normalcy, negotiating my own identity, my sense of place and orientation, in relation to a series of encounters and discussions with friends, colleagues, and strangers. Art took a backseat, to a certain extent, to the more immediate concerns of the attacks. There was a process of mourning; there were the everyday concerns of an unfolding war. We observed the ideological battle of media representations on television and the Internet; I encountered a complex mix of pro-American and anti-American sentiments. There were new

anxieties generated by anthrax in the mail, and other manifestations of one of the most complex globalized cultural conflicts to have emerged in world history. What did it mean to be a curator under those circumstances? Business as usual, or business unusual? How to negotiate through/with the world under those circumstances?

Perhaps selfishly, I have used this period of general uncertainty to reevaluate my work as a curator, writer, and educator, to take stock of the past and the present, and to seek some kind of inspiration to move forward with my work. While still in Stockholm, I embarked upon a car trip to Lund with the curatorial students, an eight-hour journey each way. Why? I used Ingmar Bergman's 1957 film, *Wild Strawberries*, as the framework for a project that accrues meaning, and unfolds signification, during the car drive. This project suggested a kind of ambulatory, movable curatorial workshop/laboratory, mirroring the narrative of Bergman's film, in which an old doctor drives to Lund (accompanied by his daughter-in-law) to receive a lifetime achievement award. The trip becomes a profoundly revelatory and life-changing experience for him, his family, and others that join the journey along the way. I have loved this Bergman film for many years, and the opportunity to retrace the car trip has proved irresistible on both subjective and conceptual levels.

Whether this project expands into an actual exhibition remains to be determined. But it has already become a way to discuss the Swedish cultural experience with a range of people in Stockholm. And, a means of reflecting upon how I developed a particular kind of understanding (or misunderstanding) of Swedish life through the exported product of the country's most famous filmmaker. Maybe there is real potential in this exhibition project, maybe not. Yet potential, in and of itself, can be fecund: to capture something just on the cusp of articulation, as it is in the process of discursive formation, just before it becomes something tangible.

To take a risk as a curator is to be open to both the possibility of not knowing an outcome, and the possibility of failure. To develop a conceptual framework for a show, yet remain open to any possible result, any imaginable visual or material destination, to embrace the ambiguities and contradictions — this risk taking can be a liberating process. It's important to unfold this process as transparently as possible, so that the curatorial framework/structure becomes, in a word, increasingly *naked* to others. If there is a common denominator among my projects, it has been the desire to articulate somewhat idiosyncratic frameworks of organization and presentation: to propose methods that deviate from familiar codes of institutional exhibition practice. Perhaps inevitably, I

have been preoccupied with the influences of cinema and television, and have also explored the possibilities of interactivity facilitated by the Internet.

In an early exhibition, *Don't Look Now* (1994-95), presented at the downtown New York City alternative space Thread Waxing Space, nearly a hundred artists, musicians, and writers were invited to reflect upon how they "project" their

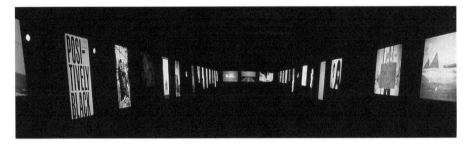

Don't Look Now, *Thread Waxing Space, New York, January 22 – February 26, 1994. Photo courtesy and copyright Thread Waxing Space and Joshua Decter.*

identities into the public realm. The title of the exhibition was lifted directly from a famous Nicolas Roeg film of the 1970s. In the opening sequence of the film, Donald Sutherland contemplates a slide of a Venetian church that he will begin renovating. After closer inspection, blood seems to emerge from a red-hooded figure at the bottom of the image; at almost the same moment, his young daughter, who happens to be wearing a red raincoat, is playing near a pond and accidentally drowns. The slide becomes a kind of premonitory device, setting into motion a series of events, at once predestined and accidental. For years, I was fascinated with this film and could not resist the temptation to find a way to use it in relation to an art project. So, for *Don't Look Now*, participants were asked to contribute a 35mm slide. Each slide was projected from an individual projector unit within a large, darkened architectural space that I co-designed with an architect/artist. The resulting effect was a frieze of glowing pictures, surrounding viewers above eye-level, and providing them with an opportunity to use these images to construct their visual syntax, to determine their interconnections and possible meanings. I attempted to rethink the group-show framework, to work with artists in a different way, to make a show without material objects, and to reflect on how the cinematic condition has affected my curatorial approach. I endeavoured to provide viewers with a unique "phenomenological" experience, to make a situation that would be visually seductive and trigger discussion.

Somewhat later exhibitions, such as *Screen* at the Friedrich Petzel Gallery (1996), and *Cathode Ray Clinic #1* at Apex Art (1996), reflected my abiding

fascination with television. There were no artworks or artists featured in *Cathode Ray Clinic #1* — just a structure for watching television. Taking a cue from David Cronenberg's movie, *Videodrome*, I wanted to give people an opportunity to take a break, or provide distraction, from looking at art in the galleries and museums. How better to accomplish this goal than to provide visitors with television — pure and simple — within the context of an alternative art space? I collaborated with a design team (Big Room) to develop the visual and physical characteristics of this TV-viewing structure. The structure was assembled in the space, and people came to Apex Art to watch tele-

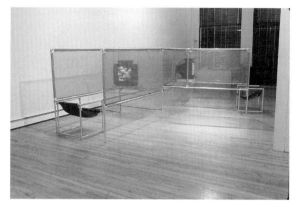

Cathode Ray Clinic #1, Apex Art, New York, May 16 – June 16, 1996. Photo courtesy and copyright Apex Art and Joshua Decter.

vision. In a sense, this exhibition was a purely transparent curatorial act: a mirroring of one of my primary activities: television watching.

For *Screen* (1996), a rhetorical meditation on the imaginary interrelations between painting and television, I collaborated with ada web to design and implement a Web site extension of the show. An interactive program was developed to generate intermixes of live daily feeds from television with reproductions of the paintings on display in the gallery, creating a layering of screens. This program was a partially successful curatorial experiment, in which the Internet, television, and painting-as-reproduction commingled. The Web extension was probably my favourite aspect of the overall project, because it opened the project up to the unpredictability of an interface with Internet users. The show has been closed for nearly six years, but people can still visit, and interact with, the Web extension of *Screen* within the ada web area of the Walker Art Center Web site.[1] One of the "magical" properties of Web sites on the Internet is that they can function as interactive archival spaces, offering a kind of ephemeral immortality for a material world (i.e., bricks-and-mortars) exhibition, a potentially endless series of interfaces with an infinite public.

In 1996-97, I organized *a/drift* for the Center for Curatorial Studies, Bard College. *a/drift* featured the work of nearly one hundred artists, as well as

so-called nonart materials (such as televisions, albums, magazines, T-shirts, and more), and included eight relatively distinct idea-zones (for example: "Elasticity," "Where is the Identity?," and "TV Heads") articulated within the framework of an elaborate exhibition design architecture. *a/drift* generated a considerable amount of press coverage, some favourable and some not, including a feature

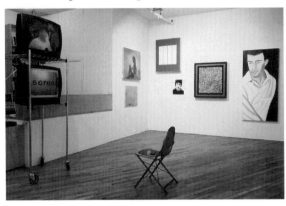

article in the Sunday arts and leisure section of *The New York Times*. The writer of the *Times's* article discussed my curatorial method of producing an interrelationship between art and non-art artifacts, linking it directly to the ongoing high/low debate in the United States. To me, this was a misreading of the exhibition, but any press is good press. Why quibble, or be a nitpicker?

Screen, Friedrich Petzel Gallery, New York, January 19, 1996 – February 24, 1996. Photo courtesy and copyright Friedrich Petzel Gallery and Joshua Decter.

Although the review was generally complimentary, the writer concluded that art could not survive in such overwhelmingly distracting circumstances. In other words, the non-art materials, in concert with the constructed environment of the exhibition design, overwhelmed the artworks: too much traffic, too much complexity, too much visual noise, not enough respect for the autonomous artworks, or something to this effect.

I was simply endeavouring to map out the possible relationship, even an imaginary interpenetration, between artworks and other cultural things, and, perhaps more significantly, to map out the idea of a porous culture, in which everything influences everything else, touches everything else. Just because a curator includes non-art materials in a show doesn't automatically indicate that the exhibition has been developed as a meditation on, or response to, the high/low issue. I was seeking to move beyond this kind of binary thinking, and to construct an edited, transcultural plenitude within the artificial environment of the museum: proposing distinctions within a veritable non-hierarchical environment.

Fundamentally, cultural institutions and museums would prefer that the "invisible" forces of contemporary art exhibitions remain precisely that — invisible. So much of what happens inside of museums, and other types of cultural

institutions, remains hidden from the public's view, and, often, even from the eyes of the specialized art crowd. Studying the history of exhibitions is insufficient: the only way to begin to understand how these institutions function — curatorially, financially, politically, socially, and so on — is to have either worked for/within an institution, or to have organized projects in conjunction with institutions as an independent curator.

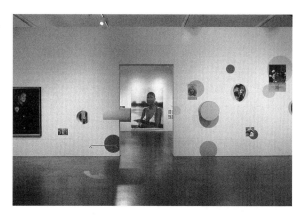

In the spring of 2001, I participated in a symposium at the MAK in Vienna, "The Discursive Museum." Within that context, I delivered a talk, "Synergy Museum" in which I suggested that art institutions might consider embracing transparency. I was making a request, perhaps even a demand,

a/drift, Center for Curatorial Studies Museum, Bard, October 20, 1996 – January 5, 1997. Photo courtesy and copyright The Center for Curatorial Studies and Joshua Decter.

for institutions to open themselves up, to become more naked and self-critical. To allow both specialized and non-specialized art audiences to peek under the institutional clothing on a regular basis (and not to always rely on importing "critical" artists to do this work). Indeed, instead of only using artists to critically *unpack* the museum, the museum should also assume the responsibility of unpacking itself in a variety of ways: reinventing, for example, how various publics might gain new understandings of institutional infrastructure.

I believe that in order to regain the trust of their various constituencies, art institutions should consider opening themselves up to the scrutiny of a curious public, so that some light can be shed upon relatively arcane bureaucratic and hierarchical structures; people might begin to develop an understanding about how, for instance, curatorial and programming decisions are reached, or, the function of the quid pro quo. Or, why so much time and money now seems to be devoted to commissioning new (putatively) vanguard architectural museum buildings (an increasingly global phenomenon, sometimes referred to as an "edifice complex" in the United States), meanwhile funds for curatorial departments are often stretched thin. Connected to this state of affairs, exhibition programming often remains tame, safe, or herd-mentality, perhaps as a result of

curators and/or fundraisers desiring to appease individual patrons, foundations, and corporate benefactors. Art institutions are public institutions (to the extent that they use taxpayer dollars), and it is their civic (and ethical) responsibility to come clean. Isn't it? Or, perhaps, as I approach 40, am I more naïvely idealistic than ever before?

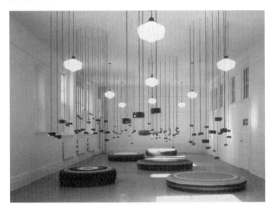

Heaven: Public View/Private View, *PS1 Center for Contemporary Art, Long Island City, New York, October 26, 1997 – February 1, 1998. Photo courtesy and copyright PS1 and Joshua Decter.*

Independent curators may be able to play a role in facilitating the development of projects that help make the self-protective institution more transparent. Of course, this would require the permission and sanction of the institution itself. But there is an uncomfortable paradox: once that permission is granted we are left with the unsettling feeling that it is merely a question of biting (or critically illuminating) the hand that feeds us. Catch-22, all over again?

The Internet does have the potential to play an important role in how institutions re-conceptualize their relationship to the public, how they engage various audiences (beyond the parochial banalities of traditional education strategies), but this will require some real nerve, and more adventurous thinking than is generally apparent today. I am not particularly optimistic, however, because it appears that the majority of museums and art institutions are using the Internet and Web sites in pedestrian and docile ways. For instance, many institutions have been taking a cautious approach to the vast potential of interactivity.

How we can invent new ways for the audience/public to interact with the museum or cultural institution, so that the mysteries of the institution are revealed? In other words, how can we create transparency of systems of authority, power, hierarchy, decisionmaking, and so forth? It is a truism, perhaps, that most institutions do not want us to see and understand these things. We understand that museums and other types of art institutions do have to consider the needs of various audiences and diverse constituencies. There may be a real pressure, at once external and internal, for art institutions to homogenize and sanitize the interactive Internet and/or Web-based experience, to make it sufficiently

engaging, visually interesting, and user friendly. Institutions cannot make things too transgressive, too provocative, too dangerous, or too *open*; they cannot risk alienating their audience (imaginary and/or real), even though the public will always be a somewhat unknowable entity, regardless of statistical analyses and polls. Museums and art institutions are always seeking to find a formula to appease a range of cultural attitudes and expectations, to balance entertainment with the project of cultural enlightenment. This is a tricky balancing act.

Often, cultural institutions take the path of least resistance; there are exceptions, of course, but the exceptions do not prove the rule. There is either a cultivation of, or accommodation to, some perceived middle ground that probably underestimates the willingness of the public to have more complex and rich interactive Web-based experiences. Experiences that might question the presumed authority of the institutional body to dictate meaning, and even go so far as to involve the "general public" as co-authors of meaning. The latter, to me, is a priority objective, and with it, the need for cultural institutions to develop multi-layered Web sites with complex architectures that provoke multiple types of interactions and penetrations. Or, the building of parasite Web sites (by independent curators and contractors) that endeavour to perforate the real/ symbolic boundaries of the cultural institution's extension into the Internet. Curatorial hacking, perhaps?

In 1999, I was invited by the Museum of Contemporary Art in Chicago to reinterpret and reinstall a selection of works from their permanent collection. This project, which I entitled *Transmute*, presented an opportunity to develop an interactive program for computer kiosks at the physical site of the exhibition, and an extension of this interactive program for the museum's Web site. *Transmute* was conceived as a platform to encourage museum (and Web) visitors to reflect on the role of the curator in relation to the institution's collection, and to provide an accessible means of allowing these visitors and Web users to function in the role of curators. I collaborated with a programmer and a Web designer to create an interactive VRML environment and program called Virtual Curator, which simulated the 3-D bricks-and-mortar galleries of the real-space exhibition. The Virtual Curator program interface allowed visitors to the on-site computer kiosks located within the museum galleries, as well as on the Web site, to manipulate — that is, *re-curate* — my show within the context of virtual/ simulated galleries. Users could fluidly reinstall artworks within this virtual architectural space, delete pieces, or leave the space blank, among other options.

Transmute was a straightforward, even transparent, curatorial gesture, reflecting my interest in offering the museum audience an opportunity to re-think my

curatorial process and decisions by interjecting their own tastes and ideas within a mutable display framework.[2] On a related level, the interactive Virtual Curator program may have triggered a symbolic challenge to my own curatorial authorship, and by extension the museum's authority, over how cultural meanings are constructed, determined, and maintained. I was eager to embrace a kind of

filtered populism, in which on-line and/or museum visitors had the opportunity, and the technological tools, to re-imagine the exhibition according to their desires and visions.

For me, this project was only a first step towards experimenting with how the symbolic and tangible interconnections between the social space of the museum and the social space of the Internet can

Transmute, *Museum of Contemporary Art, Chicago, August 21 – November 7, 1999. Photo courtesy and copyright the Museum of Contemporary Art and Joshua Decter.*

be mediated through a Web site. The Web site is conceived as a cultural interlocutor that encourages a rethinking of the *modus operandi* of the institution itself. Yes, this is a paradox. And yes, I acknowledge my complicity, but it may still be possible to make transparent — and perhaps even subtly disrupt — normative relations between institution and public, and propose a renegotiation of power. But is all this just fancy rhetoric? A kind of hyperbole of the hip curatorial set? I'm uncertain. Today, more than six months after the events of September 11th, I have begun to regain my cultural bearings, yet continue to be preoccupied with the cultural and psychological repercussions of the tragedy that unfolded in the collective backyard of all New Yorkers. Gazing out of my apartment windows, I occasionally project recollected images of that fateful morning onto the breach in the skyline. It may seem like a cliché, but it's no longer business as usual. My desire to produce exhibitions that are *necessary*, where there is something actually *at stake*, has only been amplified. To translate dreams into reality, and back into dreams.

1 See http://adaweb.walkerart.org/influx/decter/screen.html.

2 To view the Web component of *Transmute*, see www.mcachicago.org/transmute.

An independent media artist, curator, and writer, NINA CZEGLEDY divides her time between Canada and Europe. Czegledy's most recent collaborative project is *Digitized Bodies – Virtual Spectacles*, a series of on-line and on-site events in Canada, Hungary, and Slovenia. Her latest interactive digital works include the *Digitized Bodies* CD-ROM, *Aurora, Aurora* CD-ROM, and the *Y2KMonsters* interactive installation. Her *Crossing Over Workshop/Media Residency* nomadic project co-curated with Iliyana Nedkova has had six editions. The *Aurora Universalis/Makrolab* collaboration with Stephen Kovats was initiated in 1997. Recent curating projects include the touring exhibitions of electronic art installations, *Choice* (Sweden, 1999); *Touch: Touché* (Toronto, Montreal, Regina, 1999); *Gisele Trudel* (Inter/Access, Toronto, 1999); *Aurora* (InterAccess, 1998). Over the last ten years, Czegledy made videos, and curated over twenty international media art/video programs and touring exhibitions presented in twenty-eight countries. Czegledy publishes widely both in Europe and North America.

□

Trickster
The Myth and Mischief Maker

NINA CZEGLEDY

The road that the trickster travels is a spirit road as well as a road in fact.
—Lewis Hyde[1]

IN THE BEGINNING of the twenty-first century, art, science, myths, creative technology, and everyday life appear to be more intimately linked than ever before. The complexity of many contemporary undertakings seems to require alchemists or conjurers (sometimes known as curators) to successfully navigate the intricate paths of often-labyrinthine projects. In describing the miracle-making activities of the new media artist/curator, tales of the mythical Trickster come to mind.

Ancient legends of Trickster present a controversial, provocative creature, manifesting bizarre, occasionally abominable attributes. Existing on the threshold of dreams and reality, Trickster defies stereotypes. The character description offered in the following will be just as confusing and contradictory as the roles Trickster plays. Traditionally, he or she manifests multiple, hybrid personalities, and although this allegorical character is customarily portrayed as a male figure, it has been often said that the most notorious trickster is an androgynous being of indeterminate sex. For simplicity's sake, I will refer here to our myth and mischief-maker as a "he." Trickster has no fixed identity and no possessions, inhabits undefined territories, roaming the paths of ideas as well as practice.

Driven by insatiable curiosity, he facilitates change, diversity, and novelty. Trickster's use of the sacred and the profane is closely intertwined with humour and irony. He is a provocateur, a troublemaker. His labours are esteemed by some but incense others. The fabled Coyote, and the mythological figures of Hermes, Eshu, and Mercury are all well-known trickster characters.

The contemporary interpretation shows a less endearing figure. According to a dictionary definition, the trickster is "one who plays tricks: a cheat."[2] Indeed, as chronicled in folklore, he is reputed to be deceptive, but he is often the victim of deception. Yet, he valiantly reveals hidden connections and meanings by possessing the ability to open our eyes to concealed connotations. The trickster of the legends invents, arbitrates, and remakes mythologies. He is a wizard, a rascal, yet from antiquity to the present, from Japanese to Native North American folklore, tricksters have always been in evidence, their activities contributing to change, to diversity. Of course, connoisseurs of trickster lore are acutely aware of the repugnant aspects of his character, his guile, his chicanery. Although these unsavoury traits persist, the master mischief-maker is often credited as a creator and contributor to culture and the arts.

Trickster must be in his element in the rapidly developing contemporary world where nearly every phase, every aspect, and every role embodied in art practice is radically changing. These days, artists often become toolmakers, curators become entrepreneurs, venues metamorphose into virtual sites — all developing a new economy in the process. It has been often noted that Trickster travels the spirit road, inhabiting more than one world and the road between. The borderless existence of this allegorical figure (if not his repugnant traits) captivated me, as my life and work hinges on perpetually crossing lines and boundaries in both a geographical and a geotectonic sense.

In my native Hungary, tricksters were described as the "cunning folk" and included magicians, witches, and jugglers. According to folk belief, they knew "how to summon forth the dragons from their holes, how to milk the prop of the house, bewitch the hens into laying more eggs and the cows into yielding butter."[3] Although I wish to have inherited some of these special powers, so useful for working in new media, or to acquire them as suggested with the aid of a "particular object, such as a shepherd's stick or a set of bagpipes,"[4] to my regret (or satisfaction), I gained my skills, like many others in this field, through exploration, study, and practise.

Since my childhood in iron-curtained Hungary, I have longed to travel, to discover the unknown. I used to explore the world on Grandfather's old military maps. Then I joined a group of cave explorers, digging hidden connections and

mapping the concealed terrain beneath the Buda Hills. These explorations were permitted in an otherwise confined existence. Both the formal and my private borders have since crumbled, but I have never stopped investigating. The shift in the Eastern European sociopolitical situation, and a major change in my personal circumstances contributed to the beginnings of my trickster life.

It might be useful to reflect on the nature of the barriers I attempted to cross in my journey. Because of my heritage, the East-West divide remains a gap to bridge. Beyond cultural divisions, the position and work of women on both sides of the Atlantic continue to be my constant preoccupation. My training in science and art contributed to an investigative attitude and a growing interest in interdisciplinary projects. Working on the progressive edge of scientific visualization made me aware of new frontiers, and inspired my move from traditional artwork to new media. By choice, I work independently and like Nicole Gingras, I believe that independent curators are compelled to reinvent themselves for each new project.[5] The necessity of reinvention requires trickster traits:

Searching for hidden connections as a cave explorer (decades ago). Photo unknown.

optimism, flexibility, and endurance. Despite the obvious pitfalls of unaligned activities, I prefer the challenges offered by an unconventional environment, where artists, curators, and their audiences are — occasionally — able to share a specific cultural space.

My adult life, on the Canadian side of the Atlantic, began with training in medical research, studying art, and raising a set of triplets. Years later, single again, life continues with initiating and realizing multisite, multicomponent, interdisciplinary collaborations. The budget restrictions of working independently led to many adventures such as sharing the couchette on a Russian train with strange bedfellows, sleeping on a kitchen floor in Berlin, being chased by wild dogs on the streets of Bucharest, or being stranded (unexpectedly) deep in the Polish countryside without speaking the language. At the same time, the lasting friendships and the memories of eager discussions, reaching late into the Moscow or Liverpool night remain unforgettable.

◻ ◻ ◻ ◻ ◻

In the eighties, the political and economic changes of the Hungarian macro-climate became gradually noticeable. Simultaneously, on the North American continent (by then I had lived in Canada for several years), new cracks appeared in the traditional art scene.

At this time, on one of my visits to Budapest, I met Laszlo Revesz and Andras Borocz, two young artists. They and their circle produced lengthy low budget films, painted non-representational paintings (an outrageous idea in the social-realist environment), and presented performance art in a satirical, unconventional style. Perhaps it should be clarified that an abstract gesture such as covering a canvas with brown paint, constituted a political statement behind the iron curtain. Consequently, I was impressed by these revolutionary attempts in the drab socialist circumstances, and in order to reveal this refreshing trend, I began to work with Laszlo and Andras on developing a touring project.

Back in Canada, attempts were made to find a hosting organization. One day (after many tries elsewhere), I walked into the offices of Mercer Union in Toronto and submitted a proposal to the director, Steve Pozel. Over the next year, as a result of Pozel's personal foresight and courage, an "overambitious" concept of curating and touring the first postwar Eastern European experimental art works became a reality. The venture included contemporary Hungarian art exhibitions of visual art, performances, and film screenings. The project toured throughout Canada in 1984. The events were presented by Laszlo Revesz and Andras Borocz, two young artists from Budapest. On my visits to my native city, I was impressed by their paintings and performances, and we worked together to prepare this tour.

In 1984, Laszlo, Andras, and I toured Hungarian art across Canada. For the audiences in Toronto, Calgary, or Vancouver, the provocative, experimental nature of presentations from a "communist" country revealed a curious, clandestine territory.

This Hungarian project, my first attempt to bridge (in a self-initiated micro fashion) the cultural communication division between East and West, has led to many subsequent touring exhibitions, workshops, and festival and conference participations in Europe, North America, and beyond.

The end of the eighties in Eastern Europe revealed a rapidly exploding cultural climate. In late 1989, I was fortunate to participate in *Lochu Manhattanu (Caves of Manhattan)*, a landmark exhibition: the first uncensored event in a decade in Poland. Event after event followed. Beginning in 1990, from the Media Centre in Zagreb, to Ex Oriente Lux in Bucharest, to Bauhaus, Dessau,

to the Riga Video Center in Latvia, exhibitions, conferences, and festivals showcased the experimental work of East European and international artists. Art and artists from "Mittle Europe" became very fashionable in the "West."

While numerous East European new media initiatives became globally recognized, artists' access to technology remained a problem. To address this issue, the *Crossing Over (CO)* workshops I co-curated with Iliyana Nedkova were established in 1996 in Bulgaria. Now, a decade after the fall of the Wall, the ongoing *Crossing Over* project serves as another bridge over the diminishing divide. For the last seven years, Iliyana and I continued to work together on producing the nomadic media residencies and workshop events, linking Eastern European artists to the rest of the world.

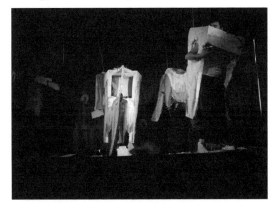

Ulysses, *performance by Andras Borocz and Laszlo Revesz, Rivoli, Toronto, 1984. Photo by Nina Czegledy.*

The fifth edition of *CO* in 2000 was hosted by the Wexner Center for the Arts, Colombus, Ohio. Five Americans and an equal number of East Europeans participated. Celebrating the digital shorts of the five workshops, the Wexner Center produced a *CO* booklet. The introduction by Iliyana and myself truly reflects the concepts undertaken in the *CO* workshops:

> *Crossing Over (CO)* operates in the dreamland where micro-enterprise and micro-revolution meet ... as a dynamic free-access framework for developing, producing and presenting video shorts, *CO* remains distinct from the mainstream venues ... *CO* is thus an independent enterprise fueled by the unlimited enthusiasm of its co-curators (a.k.a. cultural entrepreneurs working in tandem.[6]

Iliyana and I scrutinize and develop each workshop project with our participants and follow it to on-site postproduction and beyond. To date, close to a hundred artists from nineteen countries have been actively involved in the thematic residencies. This grassroots-based initiative reflects the "temporary media lab" philosophy by combining on-line and on-site, the cross-disciplinary, cross-gender, cross-national, and cross-procedural aspects of new media.

▢ ▢ ▢ ▢ ▢

Speaking of crossings: Trickster's love of chance lures him to doorways, spaces where reputedly deep-change accidents occur. In my own portal crossings, the chance to work with microscopic time-lapse movies and video recordings of cellular motility led me to time-based art. Video art attracted me, like many other women artists, because of its easy access and absence of constricting or defining history. Over the years, I made video shorts and broadcast documentaries, investigating the space between public and private events. I soon realized, however, that curating — presenting and exchanging programs — constitutes a step beyond making videos in closing cultural communication gaps. My productions in this field are outside the subject of this text, consequently, I will focus only on the curatorial aspects.

I was aware from the beginning of the outstanding talent and eminence of Canadian women artists. In contrast, women's art and women's issues, especially feminist theories were viewed unenthusiastically in Eastern Europe. My approach to publicize women's art and achievements in Eastern Europe was straightforward. I have carefully researched and curated Canadian programs by women and toured the selections from Estonia to Russia to Bulgaria. Simultaneously, I have researched, selected, and shown work from Europe in North America.

In addition to thematic and representational considerations, the touring programs conscientiously considered the prospective audience. Until recently in Eastern Europe, issues such as consumerism, community, or labour politics would not necessarily be perceived as they are in Canada. Conversely, some Eastern European concerns would not be easily understood in North America. The poetic strength, however, informing so many of the videos was clearly understood and appreciated on both sides of the pond. I have always done my utmost to present selections in person. As a result, the brief but often profound personal contacts I made while on these tours became more valuable and effective than any mediated communication.

To my delight, in the last decade we witnessed slow but remarkable changes in the appreciation of women's issues in Eastern Europe. These changes have been confirmed by exhibits, publications, projects, and festivals dedicated to the concepts and work created by women. Take for example Lindart, the Artist Women Cultural Centre, one of the newest initiatives in Tirana, Albania. The Centre was established in the beginning of 2001 and by November of the same year, *Dare to be different,* the first-ever exhibition showing the work of twenty-eight women artists from across the Balkan region was curated by Eleni Laperi and presented by Lindart.

□ □ □ □ □

Trickster is often depicted as an agent of mediation between heaven and earth, between the nonmaterial world and dirty, everyday practicalities. For the longest time, I have been fascinated by this dichotomy: the immediacy of physical presence (as in performance or embodied art work) contrasted with remotely mediated narrations such as teleprojects or, lately, the Internet. As a result, I became involved in a variety of telecommunication projects while researching and curating shows of embodied electronic sculptures. Sometimes, I combined the two polarities of actual and mediated presence within the same project via interconnected on-line and on-site participation.

Installation, Kaliska Group Manhattanu *Lodz, Poland, 1989. Photo by Nina Czegledy.*

Videobridge, the first low-tech teleproject I initiated between art students of Budapest and Toronto, was realized in November 1991 as part of the Hungary Reborn Festival. The performances were specially developed for the slow-scan projections in both cities. In collaboration with Johanna Householder of the Ontario College of Art, we used videophones for transmitting the performances to Budapest from the now-defunct Euclid Theatre in Toronto. The audiences in both locations watched the live shows and the projected images with interest and disbelief. (In Budapest the event was also televised.) To adapt to the slow-scan technology, the performers used a surprising variety of interpretative techniques, such as deliberately delayed movements. Despite the sometimes crippling technical difficulties, this venture provoked my curiosity and served as a forerunner to subsequent and more sophisticated telecommunication projects.

Cyberknitting — for all genders, curated for the Ostranenie 97 International Electronic Media Forum, wove together the ecologies of a provocative performance situation and an uncommon on-line environment. *Cyberknitting* was conceived and co-curated by the four "knitters in charge:" Iliyana Nedkova, Denis Neumand, Branka Milic-Davic, and me.

The project, presented at the Bauhaus in November 1997, aimed to be a playful yet serious exploration of gender relations as applied to (mainly, but not

exclusively) new media practices, including the Net. Our exploration was primarily directed toward a transforming Eastern Europe. How had social and gender relations changed in the context of the larger political framework? How were these issues reflected in media arts? And last but not least, do we need more humour and flexibility discussing these issues? All knitters were encouraged (via postings) to explore the cyberknitting metaphor and present their research remotely or in person at the festival. The remote visitors were invited to submit their texts and images to the Web pages. At the cyberknitting event, the invited cyberknitters (wearing handmade "knitwear" of their choice) presented a provocative video/Web/sound environment.[7] Admittedly the bizarre performance received mixed responses from the audience. Never deterred by minor hindrances, however, I persisted with more tele-investigations. These ranged from connecting artists across Canada through the *Performance Bytes Cyber Performance* event (1997), to linking up Brazilians and Canadians working in new media via the Teleanemnesis Initiative (2001).

Since 1996, in a collaboration with architect and media artist Stephen Kovats, I have been working on various aspects of *Aurora Universalis*, a telecommunication and telepresence project investigating the nature of electromagnetic forces and attempting to challenge the perceived utopia of modern telecommunications by testing the limits of technology. Within the framework of this project, I curated *Aurora*, an exhibition of installations for Inter/Access, Toronto (1998), and produced a text and CD-ROM entitled *Auroral Myth — Terrestrial Realities* (1999-2000). The works in *Aurora* were influenced by the invisible and inaudible electromagnetic energies that permeate our daily life. It was the embodiment of this concern and the exploration of the relationships between transcendental forces and everyday realities that interested me in choosing the work. Among the works on show, the "unplugged" closed circuit interior of Catherine Richards's *Curiosity Cabinet* reminded us of the constantly plugged-in state of our contemporary surroundings, while Douglas Back's flashing swishing *Black Body* measured and responded to the visitors' protective behaviour by illustrating our awareness of the changing natural and technological environment.[8] In contrast to these profound concerns, the *Auroral Myth — Terrestrial Realities* CD-ROM and text presented a whimsical approach to the mythical aspects of the legends surrounding the amazing aurora borealis, otherwise known as the Northern Lights.[9]

In the summer of 2001, a former Soviet radio telescope in Irbane — deeply hidden in the Latvian pine forests — became an experimental site for telecommunication activities. The Acoustic Space Lab provided a framework for further

aurora research including signal processing possibilities. The telescope dish was used in the radio astronomical capacity to listen and collect data on the radio emissions of various cosmic sources. Thirty-five international artists gathered for this event, and to mark the end of the workshop on August 12, 2001, a live online streaming-jamming-concert (using collected and modified accoustic recordings) was held in Riga. It was an excellent preliminary for prospective auroral concerts. Future aurora plans are in progress.

□ □ □ □ □

Some trickster tales begin in a remote land or in the heavens, but sooner or later his curiosity and his attraction to sensuality lures him back to earth. My explorations into the ether were also matched by the allure of the tactile. In our everyday life, we seem to occupy and use more and more virtual space, but there will always be artists who consider and work with physical objects, with embodied work, electronic or otherwise. So I began to explore aspects of embodied sculptures in the electronic world and subsequently curated the *Touch:Touché* touring exhibition (1999). My notions on tactility are reflected in the catalogue text:

> The invitation to touch is a bold proposition. Touching
> implies intimacy — a controversial notion in an age when
> direct contact is increasingly replaced by remote control.[10]

Confronting issues of tactility, the *Touch:Touché* project included *Bodymaps* by Thecla Schiphorst, and *Room for Walking* by Daniel Jolliffe. Interactivity with these installations required hands-on active physical contact. Aimed at fully engaging the participatory audience, the works remained lifeless objects unless direct contact was established. Both the appreciative audiences and I found it electrifying that these profoundly (perhaps even insolently) physical works, depended on real audience commitment. The control behind these pieces was subtle, yet the works were intensely physical, poetic, and at the same time ordinary.

□ □ □ □ □

Trickster generally operates on a microlevel; however, the extent of his work also depends on chance. By chance then, and as a result of the butterfly effect (with its far-reaching consequences), my initial concept for the *Digitized Bodies — Virtual Spectacles* Project — exploring the converging paths of biomedicine, arts, and popular culture — has developed over four years into an international and multidisciplinary, on-line and on-site collaboration of significant scope. This

project — the largest I have ever embarked on — asks how the digitization of our culture has been perceived and reflected on by artists, theorists, and social and physical scientists. The focus is the explosive growth of digital technologies, and how these developments have extended our consciousness and contributed to the changing perception of the human body. In recent decades, the human

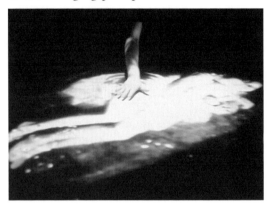

body has become a key site of scientific, social, political, and cultural interpretations. How is contemporary technoscience reconfiguring the dichotomies of nature/artifice, real/virtual, body/embodiment, and gender? Although answers to this and other questions might not be readily available, artists offer intuitive yet comprehensive interpretations of the relevant issues concerning our increasingly "visualized" culture by

Bodymaps, *Thecla Schiphorst, installation detail,* Touch: Touché *exhibition, Inter/Access, Toronto, 1999. Photo by Thecla Schiphorst.*

considering the sociocultural analysis of the digitized body.

In this project, issues of mediated representation related to the biosciences, artificial life, genetic mapping, and ethics have been examined through exhibits, performances, concerts, public forums, essays, and on-line events. The project embraced shifting notions surrounding body perceptions, material realities, and current forms of image enhancement. Close to a hundred artists, scientists, and participants from a variety of professional and national backgrounds, including students from five continents, were probing the significance of digitization in contemporary society. The artworks and texts included in the project and presented in Canada, Hungary, and Slovenia, challenged established paradigms and pointed to debates in art, medicine, communication, ethics, and technology.[11] The crossdisciplinary discourse anchored in these explorations formed a theme and highlighted the essential interconnectedness of the diverse realms covered by the various contributors.

Science and art have often been considered separate practices by both professionals and the general public. In reality, however, they are closely connected. Both disciplines examine the essence of issues with an intent to look beyond the immediate. Materials and methods might be different, but cross-stimulations are frequent and fertile for art, science, and technology. While travelling on the

spirit road, I find that most of my explorations (in my own work and in works I have curated) have focused on the intersection of these diverse yet interconnected disciplines. More than personal explorations, my intention has always been to introduce new potentialities, facilitate exchange, and initiate open-ended provocation in the true spirit of tricksters, the myth- and mischief-makers.

▫ ▫ ▫ ▫ ▫

Once upon a time, travellers used to mark crossings with cairns, each adding a stone to the pile while passing. The name *Hermes* (the messenger and also the trickster) once meant "he of the stone heap."[12] Throughout history, cairns possessed a magical meaning. I would like to believe that the con-

Intimate Perceptions, *exhibition view, Inter/Access, Toronto, 2000. Courtesy Inter/Access.*

temporary wizardry of the trickster is not only mischief-making, but also paying homage to mysterious forces of art at the crossings of ancient myths and the future.

1 Lewis Hyde, *Trickster Makes This World* (New York: Farrar, Straus and Giroux, 1998), 6.

2 Standard Desk Dictionary (New York: Funk & Wagnalls, 1977), 724.

3 Tekla Dömötör, *Hungarian Folk Beliefs* (Budapest: Corvina, 1982), 129.

4 Ibid., 130.

5 Nicole Gingras, "Parallel Voices- Free Association: Invited or Independent, Guest or Gate Crasher," in *Naming a Practice: Curatorial Strategies for the Future* (Banff: Banff Centre Press, 1996), 186.

6 Iliyana Nedkova and Nina Czegledy, "*Crossing Over (CO)* Is About Dreaming Through Video," in Ilyana Nedkova and Maria Troy (eds.), *Crossing Over* (Columbus: Wexner Center for the Arts, 2000), 5.

7 Nina Czegledy, "Cyberknitting for All Genders," in *Ostranenie97. The International Electronic Media Forum* (Dessa: Bauhaus Foundation, 1997), 234-55.

8 Nina Czegledy, *Auroral Myth — Terrestrial Realities*, exhibition catalogue (Toronto: Inter/Access Electronic Media Arts Centre, 1997), 2-4.

9 Nina Czegledy, *Auroral Myth — Terrestrial Realities,* (Liverpool: Virtual Revolutions; Audio-Visual Research Editions, 2000), CD-ROM.

10 Nina Czegledy, "Introduction," in *Touch: Touché*, exhibition catalogue (Toronto: Inter/Access Electronic Media Arts Centre, 1999), 2-5.

11 Nina Czegledy, (ed.), *Digitized Bodies — Virtual Spectacles* (Budapest: Ludwig Muzeum Budapest Museum of Contemporary Arts, 2001).

12 Hyde, *Trickster Makes This World*, 6.

IHOR HOLUBIZKY has written on a wide range of cultural topics over the past twenty years. His personal favourites include Natalka Husar, *Black Seen Blue* (Rosemont Art Gallery, 1994), a collaborative fiction with Wendy Mansell; Margaret Priest, *As Scale Diminishes ...* (Art Gallery of Hamilton, 1996); Luke Roberts, *The Mother Road* (Institute of Modern Art, Brisbane, 1999); *First Stop on the Translinear — A Wilderness Station* (McMaster Museum of Art, 1999); and *I Love a Man in a Gas Station Uniform* (Art Gallery of Peel, 2001). He also takes pride in *a ramming speed*, a 1995 independent CD of live and improvised pop and non-pop compositions with Brian Skol and Dianne Bos.

The Man Who Thought
His Myopia Was a Vision
Heliocentric Worlds, with Apologies to Herman Blount

Ihor Holubizky

HERMAN BLOUNT WAS BORN IN 1914 in the segregated city of Birmingham, Alabama. From an early age, he was known as Sonny, a straight-A student and a musical prodigy. He played in local jazz bands after graduation from high school and led his own combo, performing exclusively for black audiences. Sonny attended Alabama A&M University as a music education major, but his family could not afford tuition during the Depression. When called up for the draft in 1942, he claimed conscientious objector status. There was little tolerance for such declarations, let alone from blacks. It was the beginning of a cult mythology: considered eccentric as a musician, he was also called unpatriotic. He later moved to Chicago and in 1952 legally changed his name to Sun Ra, claiming that he was a citizen of Saturn and a thousand years old. From that point, Sun Ra pursued an idiosyncratic and independent career: a time-shifter and -shaper, with signature space theme compositions, and also the custodian of jazz legacies. His Solar Myth Arkestra was notably theatrical, wearing ornate costumes and including other stage performers.[1] The title of his two-volume album *Heliocentric Worlds of Sun Ra* (1965, 1966) can also be described as the Edge of Everything, and appreciated in curatorial terms, as itinerant curator Alvin Balkind wrote in 1981: "Galleries ... used to have at least one token crazy curator to deal with all the aberrant ideas floating around."[2] Renegades and independents have always had an unstable position within institutions; and likewise for Sun Ra. Jazz is the lesser child of the white music industry.

▢ ▢ ▢ ▢ ▢

Independent has come to mean a professional who works outside the insti-
tutional art world. This was the case at the beginning of the twentieth century,
when the first professional curators for regional galleries in Canada were often
artists.[3] The legacy has continued. AA Bronson, of the artist collective General
Idea, wrote, "As artists we had to construct not only our art but the fabric and
an art scene ... we had to develop our own *raison d'être*."[4] The first independent
to be engaged by a major Canadian institution was arguably Dorothy Cameron
for the National Gallery of Canada (NGC).[5] Her centennial exhibition,
Sculpture 67, was not mounted within the institution, not even within Ottawa,
but at Toronto's Nathan Phillips Square and High Park. The exhibition was shut
down after a few weeks. There were many reasons for this closure, but art critic
and writer Robert Fulford proposed that Cameron and the exhibition had been
abandoned as a new NGC administration distanced itself from the decisions of
the old one.[6] Balkind, Cameron, Michael Greenwood, Anita Aarons, and others
belonged to a between-the-wars generation who encouraged cultural explo-
ration — crossdisciplinary and interdisciplinary — and saw the importance of
mentoring for emerging curators. Whether Balkind and others worked inside
or outside an institution, they brought their independence with them, an
expression coined by Brazilian curator Paulo Herkenhoff.[7]

During my formative years in the 1970s, I saw Sun Ra at the Horseshoe
Tavern in Toronto. The event was a compelling oddity, with its conclusion
providing a soundtrack for my professional wanderings, the spectacle of the
Arkestra members weaving through the sparse audience chanting, "We travel the
spaceways, from planet to planet." The chant was infectious, a mantra. As curators
often choose or borrow a phrase and make it their signature through repetition.

I managed a commercial gallery, the Electric Gallery, Toronto (1974-79),
which became unviable; held various curatorial posts at the Art Gallery at
Harbourfont, an illegitimate public gallery (an offshoot of a Federal Liberal
election gift to "the community" which began operation in 1974 it was not held
in high regard at the outset by other art professionals), that became legitimized
as the Power Plant (1979-88); was curator for the Art Gallery of Hamilton
(1989-97), a generalist, regional museum; and then a curator for the high-
profile, but upstart Museum of Contemporary Art in Sydney, Australia (1999).
There were also many independent moments, self-generated exhibitions, and
collaborations with artists in North America, Europe, Brazil, and Australia. This
mix was a way of keeping myself honest, less institutionalized. The following

curatorial path is presented as a chain of incidents, heliocentric worlds at the edge of everything.

1. Over the shoulder at the moment of creation

The American artist Robert Watts mounted his audio-electronic-video installation, then titled *Canadian American Sky*, at the Electric Gallery, November 1974. I was aware of the general theoretical aspects of his work — and his association with Fluxus — that elements could be drawn from the world and off the shelf. But working as his assistant at close quarters was a practical undertaking. The public stage and artist transforming the gallery to their own purpose was revealed to me. These are not metaphors. *Canadian American Sky* was performative and interactive, a live video feed triggering a computer-music program. Conventional aesthetics were nonexistent. It was a swift entry into the vanguard, my first direct experience with Concept. Watts's concept could, as technology changed, find any form, be transformable, expand and contract.

2. The shoulder shrugs

Before *Six Propositions (for Communicating)*, mounted in 1980 at the Art Gallery at Harbourfront, my curatorial work had been under the aegis of the Electric Gallery, predetermined by the medium even with the latitude offered. *Six Propositions* was independent thought — albeit drawn from experience — but was, in fact, a single proposition — mine, as curator. Robert Watts was one of six invited artists, and all but one was known to me from gallery experience. The first shoulder that shrugged was Watts's, his reaction when I asked him to be present for the art critic. He resisted; he was not interested. Believing that courting the art critic was part of the game, I was rewarded with a blast from the pen.[8] Curators, like artists, embrace the positive review and cringe at the negative. The demonic press is not a rule of the game, but an ever-present taunt.

The experience haunted me for years. Had I done something wrong? Had there been, in *Cool Hand Luke* terms, "a failure to communicate?"[9] On reflection, the smallest work in the exhibition, a beta-ray detector by Watts, could have stood for my concept — a cigarette pack-sized device that beeped whenever errant cosmic rays (from the spaceways) struck it. Why bother with a twenty-year-old exhibition can be answered by the importance of learning from mistakes and errors in curatorial judgment. *Six Propositions* was a critical juncture. My understanding of artists' intellectual property was imprecise, but I quickly learned of the artists' will and independence, different from the private gallery sector where the primary objective is a mutual, financial well-being. I

saw the shortcomings of curatorial journalism and attempting to define work that was still in progress. Years later, I came across Hugh Kenner's warning, the gallery's impatience with "the test of time [and curators] hoping to catch creativity on the wing."[10] The inherent problem in assembling a group, and why I now make a distinction between a group exhibition (what artists construct by association) and a grouped exhibition (what curators assemble, often believing it constitutes a group); artists must not lick the curator's stamp of approval.

Modern Art: A Misrepresentation, *Art Gallery at Harbourfront, Toronto, 1985. Installation view photographed by Ihor Holubizky.*

Virtually every other Harbourfront exhibition until the Power Plant opened in 1987, was book-ended by strength of will and paucity of funds. Again, necessity showed itself to be the mother of exhibition invention.

The earnest effort to weave momentum from social-aesthetic ideas culminated in *Modern Art: A Misrepresentation* (February 22 to March 31, 1985), an exhibition of international commercial billboards. It was presented as an "environment," as if it were constructed by an artist, art without artists. As curator, I also consciously stepped over the line, speaking of art in the public realm. The life and meaning of those billboards — though ephemeral by nature (media companies do not keep "archive" copies) — continued beyond the exhibition. I donated the remaining billboards in 1998 to the University of Buffalo Art Gallery. Some were used by the University of Buffalo in forming another cultural perspective, an exhibition titled *Persuasion: Tales of Commerce and the Avant-Garde.*[11] *Modern Art* made its point, at the time and after, but I did not repeat it, having the opportunity within institutions to do different things. The pitfall for the independent-outsider is twofold: dependence on the institution to accept and mount an exhibition; and repetition, being encouraged by yet other galleries to repeat a successful exhibition with minor variations, as galleries go shopping for "fresh" ideas.

3. The reversal of the curator's fortune

As *Modern Art* opened, I took a brief sabbatical, starting in West Berlin and staying at the apartment of British artist Eric Snell and his partner Joanna Littlejohns, an independent curator. That year, Eric had received a DAAD grant, the Berlin visiting artist-in-residence program. Much of our time was spent in conversation and in tourism with a professional calling card. One evening we went to the opening of Jaroslaw Kozlowski's exhibition at the daadgalerie. It was the same crowd I had seen since arriving, as familiar as any Toronto opening. There was an array of slight installations, plastic potted plants, and wall drawings of a quasi-architectural nature. Kozlowski was in a separate

Curatorial Laboratory Project #6, Glut: Culture as Accumulation, *guest curator Gary Michael Dault, Art Gallery of Hamilton, 1991. Installation view photographed by Ihor Holubizky.*

room, visible through a locked glass door. He stood, playing a violin. We all peered in and made comments. Was he intentionally playing badly?

Months later I received the catalogue from Eric, and saw myself in one of several first-night photographs reproduced. Another mystery. Early the following year, I returned to the Berlin apartment and saw, hanging on the wall, a large framed Kozlowski photowork: it was the catalogue image in which I appeared, with the "group" outlined in gold marker. The performance had been a distraction. The artist had caught the curator on the fly, one of many flies caught that evening. Kozlowski had enlarged the photographs taken surreptitiously at the opening and mounted them in gold frames. Attached to each frame was a brass plaque with the number "1985" (the year the piece was executed), and a different national currency sign preceding the date/number: $1985, £1985, Y1985, Sfr1985, and so on. The opening crowd returned to review themselves in the second part, titled, *The Exhibition*. The third part was *The Auction*: Kozlowski tapped into market manipulation and the deep well of art-world egos — to be immortalized in art. Eric Snell attended and elaborated: "We all knew the carrot that was being dangled ... but still everybody wanted to get a work."[12] The price on the plaque

was the opening bid, but it fluctuated depending on the relative exchange value of the currency. All the works were sold. Commodification was not a new issue, but Kozlowski had neatly summarized and named the parts: *The Show* (the opening); *The Exhibition; The Auction; The Catalogue.* He had sidestepped "The Dealer" and "The Critic," and he had stepped over "The Curator." It was a

humbling experience: again, an example of the artist's will, constructing the art world independently, albeit within the largesse of public funding.

4. More humble pie
In the early 1980s, G.J. — a Toronto art dealer — and I struck up a friendship. I admired his personal interest, even obsession with the works he acquired, which provided a tonic for

Small Villages, *The Issacs Gallery in Toronto, 1956–1991, and Art Gallery of Hamilton, 1992. Installation view of the top of the bridge photographed by Ihor Holubizky.*

the market-spectacle side of the art world, ironic in light of the former incident. A small Tony Scherman painting caught my eye, and I saw it often when visiting his apartment. Years later, I stared at it once again and blurted out, "It's an apple." G.J. barely raised his head, and replied in an understated tone, "What did you think it was?" My answer would have been "a painting," and if pressed to elaborate, I would have rattled on about its composition, gesture, and materiality. The incident may appear to be minor, but it was a reminder that curators need to keep looking and asking questions, and not jump to conclusions.

My final gesture at Power Plant was a proposition about the impermanent collection, to bring anomalies, quirks, and errant trajectories of art and the underknown into the relative orthodoxy of the Power Plant's program. I brought the idea forward again at the Art Gallery of Hamilton. Unlike the Power Plant, this gallery had a history of custodianship and a storehouse of many objects; some acquired with intent, others coming to rest. Renamed the *Curatorial Laboratory Project*, it was accepted by the director because it seemed so innocuous, more selections from the collection. I invited four independent outsiders to collaborate and participate in a series of eight exhibitions: artist Oliver Girling; critic Donna Lypchuk; writer, critic, and artist Gary Michael

Dault; and artist and writer Jennifer Fischer.[13] They were asked to construct an exhibition-installation based on collection works, and were given free rein within certain parameters, ten works maximum, and a designated gallery space. They could support their selection in any way, be it art-historical, theoretical, or fictional. The final two guest instalments demonstrated how far the invitation terms of reference could be stretched.

Dault arranged for a recon-struction of one of the sculp-ture storerooms and titled the installation *Glut: Culture as Accumulation*. Fischer brought out everything in the col-lection by a single artist, Robert Downing — a *gesamkunstwerk* — including the artist's voluminous autobio-

David Bolduc studio, Toronto, Summer 1982. Photo by Ihor Holubizky.

graphy binders. In both cases, the visitor was not presented with a prescribed selection to direct them to a singular concept, but allowed to experience a raw state.

The experience of the *Curatorial Laboratory Project* offered a way of approach-ing a subsequent Art Gallery of Hamilton exhibition, dealing with the thirty-five year history of the Isaacs Gallery in Toronto.[14] The centrepiece was a prop, a bridge twenty metres long and four metres high, built of industrial-palette racking and Dexion.

The bridge served as open storage for "minor" objects selected from artists and Isaacs's personal collection (an American 1930s "Tramp art" chest, for example), and a way for the visitor to pass over the gallery space with a vantage point from above. Standing on the bridge on the eve of the exhibition opening, looking at the accumulation below and beyond, former Isaacs Gallery artist Mark Gomes dropped the comment, "We [as artists] are responsible for our own inventory." What then of the curator's role as custodian of artifacts or generator of concepts?

5. The *horror vacui* of infinite possibilities[15]

I left Canada in April 1998 and returned for one year in 2000 to put concepts for a model centre for cultural research to the test.[16] During my time away, a

conceptual model had emerged in conversation with artist Alexander Pilis, an expatriate Brazilian and Torontonian, living in Barcelona. Our meeting — during the opening week of the 1998 Bienal de São Paulo — seemed appropriate and ironic as the conversation turned to our respective and mutual experiences in the Canadian art world. The final proposition — titled *oo* — was squeezed out over

e-mail exchange. Framed as the portent for year 2000, the name was also a play of words, the binary stutter, and the sign of a watcher with field binoculars.

oo was conceived as a theoretical and social-aesthetic enterprise, to be actualized as an informa-tion centre through which ideas from a wide range of disciplines could be soli-cited, organized, and main-tained. It would generate cultural traffic, encouraging and supporting the devel-opment of projects and

Jerusalem, outside the Old City, summer 1992. Instead of "doing Documenta" that year, I decided to go to Israel. The photograph of the market is not art or exhibition related, but one of many photographic working notes that are important in my curatorial perspective. It is a reminder of questions that need to be raised – what am I seeing; what does this mean? Photo by Ihor Holubizky.

events. *oo* was framed as a complement to the museum and its principles to collect, conserve, exhibit, and educate. Although fundamentally sound, there are intellectual (and financial) limitations for all gallery enterprises. And no matter how often a gallery mission statement is revised to embrace the shifting ground of cultural practice, artists will act independently of those agendas.

Rather than *oo* being a curatorial-programming subdivision of the gallery/ museum — a further dilution or fragmentation of resources — when appropriate and feasible, we conceived that *oo* could operate independently and outside, to freely experiment and deal with what might otherwise be considered aberrant ideas. *oo* did not take root when presented to a potential host gallery. *oo* was conservative in accepting a degree of status quo, but radical in its open architecture. The unknown is not how galleries and museums work.[17] The edge is too risky; artists too unpredictable, too unruly, ideas can be transgressive; they undermine authority, can be politically incorrect, enrage, and infuriate. This is true of the blue-chip museum and the journalistic temporary-

contemporary gallery. They hire curators to serve the mandate. My experience showed that cultural research is measured — that quantitative leaps are not easily accepted, or in the example of the *Curatorial Lab*, must be cloaked.

6. My life in a hole ...[18]

Australian artist, writer, and curator Edward Colless and I were thrown together in mid-1999. Before my arrival at the Museum of Contemporary Art (Sydney), Colless had been contracted to develop an Australian component to the Oxford Museum of Modern Art international travelling exhibition *Notorious: Alfred Hitchcock and Contemporary Art*, but Oxford MoMA insisted that it could not replicate their premise or intellectual property.[19] As production manager, I was responsible for a

Yuri Albert studio, Moscow, April 1988. Albert does a show-and-tell for the visiting curator. A magazine article, as report, was published: "Myths and misses: making art in Moscow," ETC Montréal 5, (Autumn 1988): 43–45. Photo by Ihor Holubizky.

triparty negotiation: the demands of Oxford MoMA; the responsibility to the MCA; and providing assistance and support to Colless as the outside curator. Not surprisingly, practical and financial limitations framed Colless's component, which was solved with high audacity and minimal means and titled *Moral Hallucination*.[20] The siting of a problematic video/audio/strobe work by Tasmanian artist Matt Warren, then residing in Vancouver, was an example of "minimal" means. At the outset, the MCA had vetoed the expense of constructing a wall in which to enclose and isolate the audio and strobe light aspects from the other works. A box/plinth enclosure had been constructed as a compromise, but it proved unworkable: the plinth looked awkward. Colless's solution was to cut a jagged hole through a gallery wall and install the work in an existing cavity. The viewer had to peer through to experience, literally, on the other side of the public space. The MCA agreed to this labour-intensive and last-minute request, yet had resisted a much simpler and justifiable request: to forgo conventional museum wall labels. (How can a "hallucination" be labelled?) In the scheme of things, the two incidents are not earth-shattering; they are even rather commonplace.

But it was a sign of divergent and inconsistent trajectories. The curator, inside, can be the outsider, and we all end up sticking our heads into a wall.

Where to end.

□ □ □ □ □

Germaine Koh at Harry's Cafe de Wheels, during the Biennale of Sydney, September 1998. Germaine and I had previously corresponded on other art professional matters, but this was our first face-to-face encounter. I was writing a review of the Biennale for Canadian Art, *and later a feature article on her work. Harry's is a Sydney Harbour landmark, the equivalent of the roadside diner for takeout. It is located across from Artspace, where Germaine's work was installed. Their specialty is meat pies. Photo by Ihor Holubizky.*

Curatorship may be a profession, but try explaining it to an Egyptian fisherman.[21] And if a brotherhood, it can be a monastic order. Primary work — research and development — takes place in the real world, but other tasks are often completed in solitude at a computer. Writing, which I have not foregrounded, is a critical aspect of curatorial practice — not to mention the constant personal and institutional struggle to find the right exhibition title — another way of organizing and presenting ideas.

The curator may be relieved to see some texts finally leave the desktop, or feel separation pangs for work that may have been a constant companion for several years. The words will land, like seeds on a heliocentric world. Some may flourish, and others wither and die. There is no way of knowing, and words alone — no matter how passionate or erudite — cannot guarantee the success of the crop, its cultural fecundity. American professor George Kubler summarized the gap between object and interpretation:

> A work of art is not only the residue of an event but it is its own signal, directly moving other makers to repeat or to improve its solution. In visual arts, the entire historical series is conveyed by such tangible things, unlike written history, which concerns irretrievable events beyond physical recovery and signalled only indirectly by texts.[22]

Rarely is there any sense of completion, or clean slate for the text or the exhibition. Writing may end simply because there is a deadline, and once an exhibition is mounted, there can be second-guessing: Was this the right selection? The best possible installation? The curator rarely stops thinking, but curiosity will remain at the edge, until the institutional string is pulled. And should you declare, no more — cut the string — you are invisible, travelling the spaceways from planet to planet. Sun Ra's advice may have been to eat more purple food.[23]

1 See Robert Campbell (Clemson University), "From Sonny Blount to Sun Ra: The Birmingham and Chicago Years," www.dpo.uab.edu/~moudry/camp1.htm. Sun Ra's ensemble was known, at different times, as Arkestra, Solar Arkestra, and Solar Myth Arkestra.

2 Alvin Balkind, "The Long Rhythms," *Vanguard* 10, no. 8 (October 1981): 18. Balkind, born in Baltimore in 1921, established the New Design Gallery in 1955, the first major contemporary commercial gallery in Vancouver. He was appointed curator of the Fine Arts Gallery of the University of British Columbia in 1962, introduced a museum training course for advanced students in 1964, and subsequently held curatorial posts at the Art Gallery of Ontario (1973-75) and the Vancouver Art Gallery (1975-78). He died in 1992.

3 Artist, historian, and former curator for the Metropolitan Museum, Roger Fry was an independent curator for his seminal Post-Impressionist exhibition mounted at the Grafton Gallery in November 1910 in London, England. In a comparable way, the American photographer Alfred Steiglitz created a curatorial proposition by declaring the Photo Secession and opening a New York gallery dedicated to his vision in 1905. Three examples of Ontario regional gallery artists-curators were T.R. MacDonald, Art Gallery of Hamilton, 1947-73; Clare Bice, (now) Museum London, 1940-72; and Kenneth Saltmarche, (now) Art Gallery of Windsor, 1960-85.

4 AA Bronson, ed., *From Sea to Shining Sea* (Toronto: The Power Plant, 1987),10.

5 Cameron had closed her Toronto gallery after obscenity charges were laid against her *Eros 65* exhibition.

6 Robert Fulford, "RIP," *artscanada* 24, no. 8/9, (August/September 1967). Cameron went on to organize another outdoor exhibition in1969 for the (then) Rothmans Art Gallery of Stratford and soon after retreated to private worlds, still at the edge, but as an artist. She died in January 2000. See Ihor Holubizky, "Dorothy and Anita: There Ain't Half Been Some Clever Bastards," *Lola* (Summer 2000): 15-18.

7 Greenwood was director/curator of the Art Gallery of York University, 1968-84; Aarons, the founding director of the Art Gallery at Harbourfront, Toronto, 1975-83. Paulo Herkenhoff was the chief curator of the 1998 Bienal de São Paulo. His response to the Bienal board, when told that he would be given his independence in organizing the Bienal, was, "I bring my independence with me." (From a conversation with the author.)

8 John Bentley Mays, "Gizmos Too Cute to Say Anything," *Globe and Mail*, December 2, 1980; Liz Wylie, "Six Propositions," *Artmagazine* (February/March 1981): 20-23.

9 *Cool Hand Luke*, U.S., 1967, director: Stuart Rosenberg. It contains the memorable piece of film dialogue: the sadistic prison guard played by George Kennedy, says to the antihero convict, played by Paul Newman, "What we have here is a failure to communicate."

10 Hugh Kenner, "Epilogue: The Dead-Letter Office," in Brian O'Doherty ed., *Museums in Crisis* (New York: George Braziller, 1972), 170.

11 Mounted September 17 to November 14, 1999.

12 E-mail correspondence with the author, June 2001. Former American DAAD resident and Fluxus artist, Emmett Williams, was the auctioneer.

13 The *Curatorial Laboratory Project* exhibitions ran from April 1990 to January 1992. My part was to organize four thematic temporary-contemporary exhibitions — *Numbering, Word Perfect, Practicing Beauty, and Atlas* — selecting works for each "theme" that were not represented in the extant collection.

14 *Small Villages*: The Isaacs Gallery in Toronto, 1965-1991, presented September 10 to November 10, 1992.

15 A phrase coined by Dr. David Moos, curator at the Birmingham Museum of Art, in e-mail correspondence with the author, February 2000. *Horror vacui* is the fear of open space, or the abhorrence of a void.

16 In 2000 I was senior curator at the Kelowna Art Gallery.

17 The information bedrock for the collecting gallery is the object file, grouped by accepted subject fields. The fields break down as artists (invariably) engage different areas of interest and hybridized production. For the temporary-contemporary gallery, the catalogue (if produced) and production file are the key documents. Other institutional ideas are present in catalogues if exchanged or gathered on a regular basis. The problem lies in the means of gathering other information. Items may be clipped for thematic or chronological files, a means of tracking the shifts in the exchange economy of ideas, or raw material for exhibition development. But the task of keeping up such files is daunting and a low priority. Exhibition development, however, focuses on achievable production, and unsuccessful proposals — including those of merit — may be recorded in a perfunctory way. But the support material is often returned or abandoned. Ideas are left to the memory and will of the committed individual. Ultimately, the document of record is the program; what is produced, not ideas and concepts.

18 A reference to the African Head Charge album, *My Life in a Hole in the Ground*. On-U Sound, London, 1981.

19 It was a vague term, even more so as the exhibition was a rehash of *Hall of Mirrors: Art and Film Since 1945*, Museum of Contemporary Art, Los Angeles, 1996.

20 I learned that audacity was one of Colless's trademarks. He had titled a compilation publication of his essays, *The Error of My Ways* (Institute of Modern Art, Brisbane, 1995).

21 A true incident, while travelling in Egypt in 1985.

22 George Kubler, *The Shape of Time, Remarks on the History of Things* (New Haven and London: Yale University Press, 1962), 21.

23 Sun Ra believed people would be healthier if they ate more purple food. Campbell, "From Sonny Blount to Sun Ra: The Birmingham and Chicago Years."